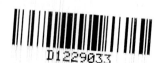

D1229033

Fiamma Domestici

DELLA ROBBIA
A FAMILY OF ARTISTS

SCALA/ RIVERSIDE

CONTENTS

The illustrations for this volume come from the SCALA
ARCHIVE, which specializes in large-format colour
transparencies of visual arts from all over the world.
Over 50,000 different subjects are accessible to users by
means of computerized systems which facilitate the rapid
completion of even the most complex iconographical
research.

© Copyright 1992 by SCALA, Istituto Fotografico
Editoriale, S.p.A., Antella (Floence)
Translation: Christopher Evans
Editing: Karin Stephan
Layout: Fried Rosenstock and Ilaria Casalino
Photographs: SCALA (M. Falsini and M. Sarri) except:
no. 51 (New York, Metropolitan Museum of Art); no. 54
(Berlin-Dahlem, Gemäldegalerie); no. 56 (London,
National Gallery); nos. 79, 80 (Florence, D. Ringressi)
Photocomposition: "m & m", Florence
Colour separations: RAF, Florence
Produced by SCALA
Printed in Italy by Amilcare Pizzi s.p.a. - arti grafiche
Cinisello Balsamo (Milan), 1992

1. *Luca della Robbia*
Coat of Arms of the Stone-Masons' and
Wood-Carvers' Guild
diam. 180 cm
Florence, Church of Orsanmichele

NB
623
A72
D64
1992

1

Luca della Robbia: his life and most important works

It is no accident that, after the eulogies that he received during his lifetime and from his contemporaries, Luca della Robbia was to reach the peak of his fame and critical success in the second half of the last century, with the help of the moralistic atmosphere of a "purist" and "Pre-Raphaelite" stamp that prevailed at the time. In 1893 this even led a pupil of Ford Madox Brown, Sir Harold Rathbone, to set up a new della Robbia workshop in the town of Birkenhead, near Liverpool: the "Della Robbia Pottery and Marble Company" specializing in the embellishment of architecture and interior decoration in the style of the della Robbias.

This company, which was able to count on the support of outstanding figures in British artistic culture such as Leighton, Morris, and Hunt, was to have a short life, being wound up in 1906. Nevertheless it is still the most tangible evidence we have for the high esteem in which the art of the della Robbias was held and for the success that was achieved by Luca della Robbia, its initiator, in an age in which religious sentiment played a central role in both Italian and foreign art, and in which "primitive" artists were used not only as a model of style but also held up as examples of ethical and social conduct.

3

2

2. Donatello
Cantoria
Florence, Museo dell'Opera del Duomo

In fact Luca della Robbia (Florence, 1399 or 1400 - *ibid.*, 1482) had a long and fruitful life, extending over the first eight decades of the fifteenth century and devoted exclusively to work and to the continual practice of his art. An orderly life, free from eccentricities, major distractions, or moments of rebellion; a life in which he gained recognition for his talents but one that was also filled with labor and sacrifice, as Vasari faithfully records: "[…] he devoted himself wholeheartedly to sculpture so that he never did anything but chisel all the day and draw at night. And he did this with much diligence, so that many times, feeling his feet freezing at night, and not wishing to leave his drawing, he used to warm them by keeping them in a basket of wood shavings, that is of those parings that woodworkers cut from the plank when they are working with the plane." His well-known moral integrity, sustained by a deep religious faith, calm and serene temperament, as well as his undisputed talent as a sculptor in marble, bronze, and terracotta form the basis for the high regard and fame enjoyed by the artist in his own time and over the following centuries.

Like Brunelleschi ("of very gaunt form" according to Vasari) and even Donatello, he was not a handsome man. The title page of the *Life of Luca della Robbia* written by Vasari bears his portrait: a rather flattened and aquiline nose, a frowning expression on his face. But beneath the unprepossessing appearance of this "confirmed bachelor," like Donatello or Botticelli, was concealed "a good Man of great intellect who led a decent life," as Antonio Manetti described him around 1487.

Coming from a well-to-do family of wool merchants that owned land and real estate in the Valdarno, Luca della Robbia was born in Florence in 1399 or 1400, as can be deduced from the declaration to the cadastre made by his father, Simone di Marco della Robbia, in 1427. Along with his two older brothers, Marco and Giovanni, he grew up in the parish houses of San Pier Maggiore, on via Sant'Egidio. A contemporary of Masaccio, and younger than Donatello and Brunelleschi, he enrolled in the Wool Guild at the age of twenty-six. In 1432 he entered the guild of the Stone-Masons and Wood-Carvers. Around 1450, he made

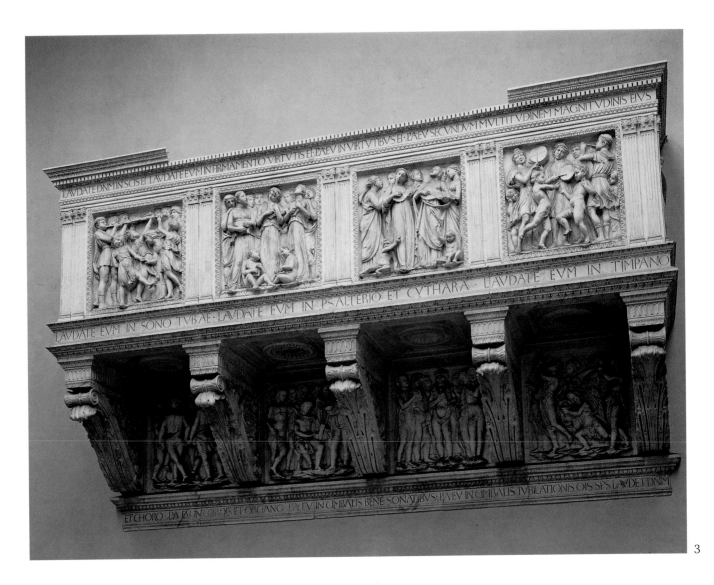

3

3. *Luca della Robbia*
Cantoria
348x570 cm
Florence, Museo dell'Opera del Duomo

a *Coat of Arms* for that guild out of glazed terracotta with a flat decoration, to be mounted in Orsanmichele, probably as a replacement for an earlier one that was executed in paint or mosaic.

His enrolment in this guild, which protected the interests of all those in the city involved in activities connected in any way with building, and which in 1410 had commissioned from Nanni di Banco the tabernacle with *Four Crowned Saints* for its niche in Orsanmichele (the severe classicism and sense of *romana gravitas* of this work did not fail to have an influence on Luca), has to be seen — as has already been pointed out by Pope Hennessy (1980) — in close connection with the first important commission received by the artist in Florence: the *Cantoria* or *Singing Gallery* for the Cathedral.

It seems that in those times there was no escape for those who fell foul of the guild laws. Even Brunelleschi, who had refused to pay the annual levy to the Stone-

Masons and Wood-Carvers, was arrested on 20 August 1434 and thrown into prison. It was the Cathedral Vestry Board, worried that the work on the dome commenced by the celebrated architect would not be completed, that got him out, after eleven long days of imprisonment.

In 1446 Luca and his brother, the wool-worker Marco di Simone, purchased a bigger house on via Guelfa for the sum of two hundred and twenty florins. This, as we shall see, was to become the location of the della Robbia kiln and workshop. On several occasions he carried out commissions for the Guild of the Stone-Masons and Wood-Carvers. In 1472 he is recorded as one of the 106 members of the Confraternity of St. Luke (the famous association of artists in Renaissance Florence), along with Donatello, Verrocchio, Botticelli, Pollaiolo, Ghirlandaio, and Leonardo da Vinci. In the previous year, however, already old and infirm, he had been obliged to give up his public posts (*quod sine periculo sue persone dictum officium commode exercere non posset*) and draw up his will.

Thus, as Vasari was to recount (1550), "cruelly afflicted by disease of the kidneys, no longer able to resist the pain that this sickness caused him, he passed from

5

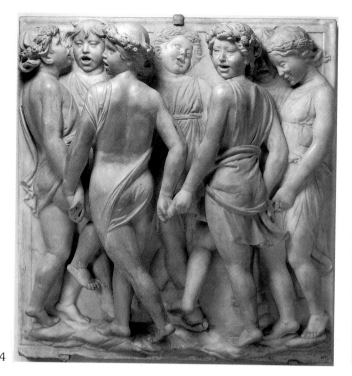

4

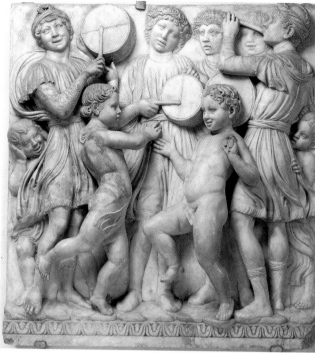

5

4. *Cantoria*
The Choral Dancers

5. *Cantoria*
The Drummers

6. *Cantoria*
The Choral Dancers, detail

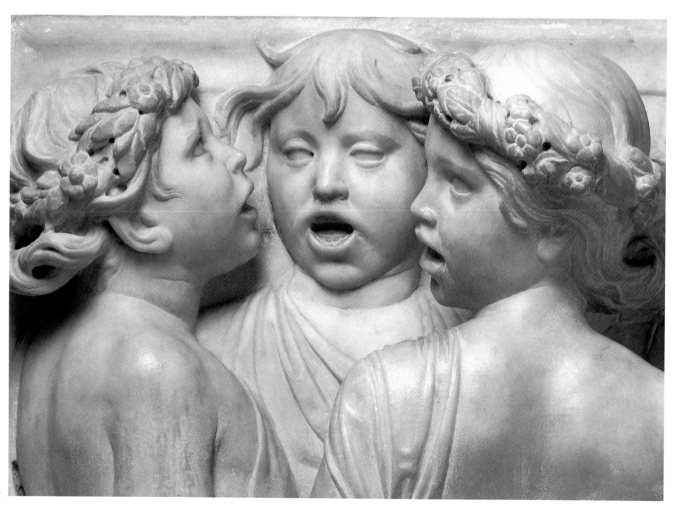

6

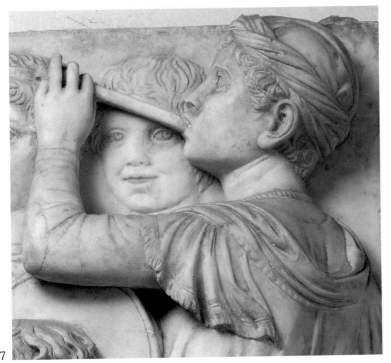

7. *Cantoria*
The Drummers, detail

8. *Cantoria*
The Tambourine Players, detail

9. *Cantoria*
The Cymbal Players, details

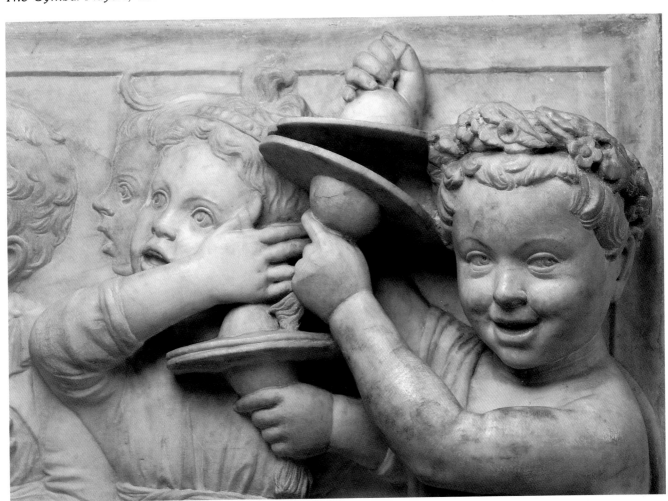

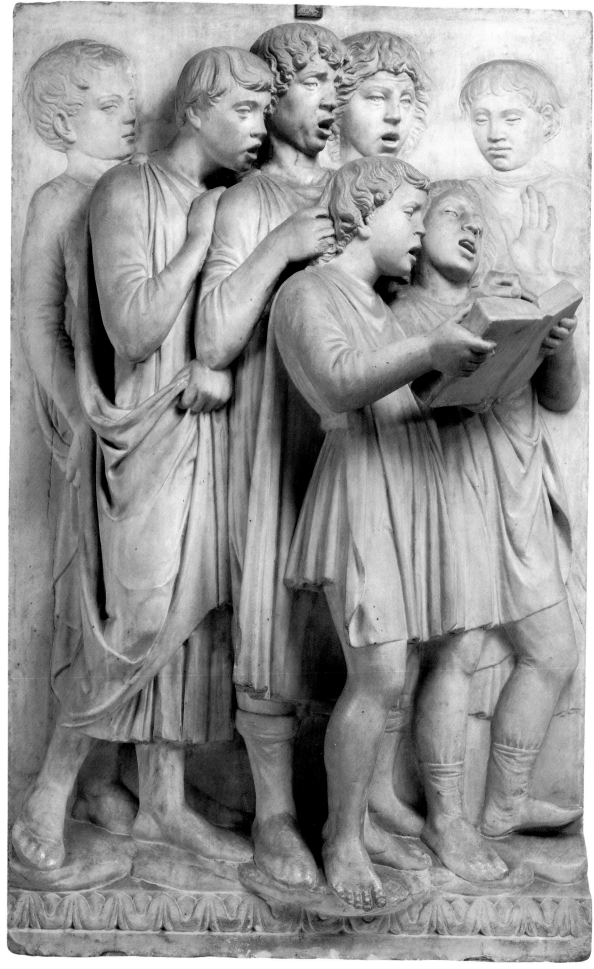

10

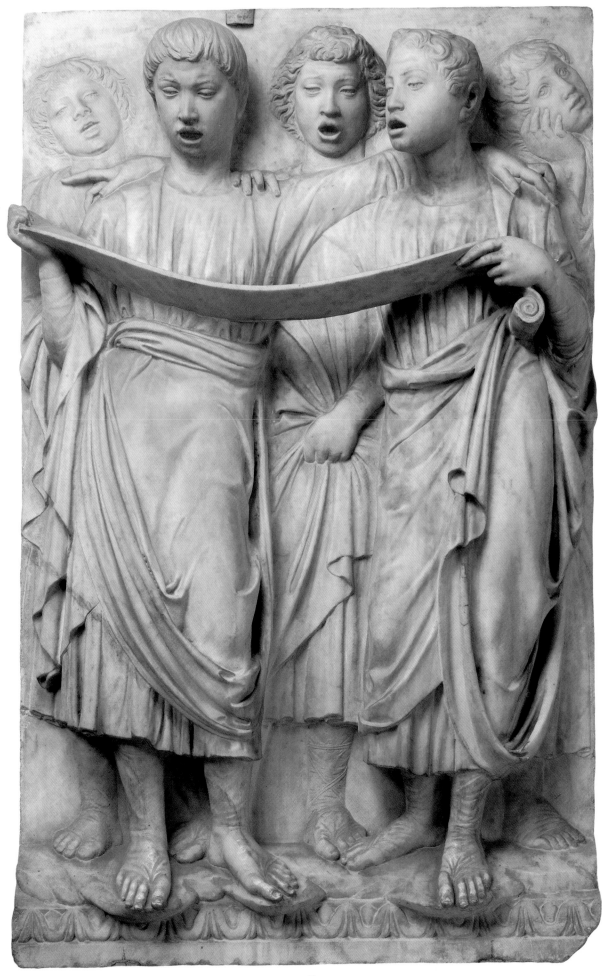

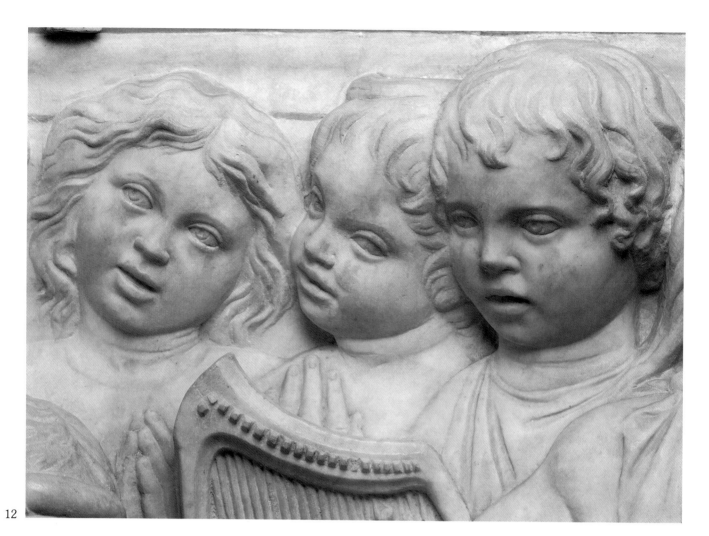

12

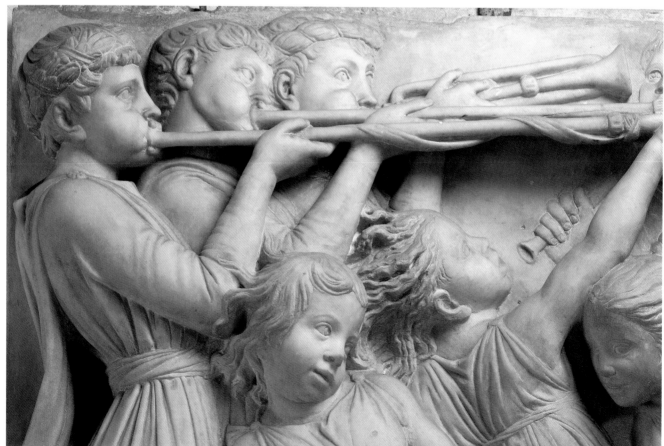

13

10. Cantoria
Boys Singing from a Choir-Book

11. Cantoria
Boys Singing from a Scroll

12. Cantoria
The Players on the Organ, Harp and Lute, detail

13. Cantoria
The Trumpet Players, detail

14. Luca della Robbia
Philosophy
Florence, Museo dell'Opera del Duomo

15. Luca della Robbia
Grammar
82.5x69 cm
Florence, Museo dell'Opera del Duomo

this to a better life." It was 20 February 1482.

This brief account of Luca della Robbia's life already paints a picture of a man who played a full part in the cultural and political activities of his city, and who soon revealed himself capable of giving to his fellow citizens the assurance of a serene dominion over the passions in the name of the superior strength of reason and the intellect. A dominion that, linked to the humanistic dream of the early Renaissance, slowly faded in the second half of the century and which one looks for in vain in Donatello and his sympathizers.

So the constant and active presence of Luca della Robbia in Florence signified for that city — famous for its quarrels and as loath as ever to accept innovation and radical change, with the result that many of its artists and other favorites, from Ghiberti to Donatello to Masaccio (to mention just a few names) were obliged to go elsewhere — a guarantee of restraint and classical equilibrium: his moderate renewal of style, combined with the confidence to look ahead without denying a

still recent past on which people did not yet wish to completely turn their back. This explains the esteem and high reputation enjoyed by the artist in the religious and cultural circles (especially the erudite circle of a Neoplatonic stamp at the Medicean court) of the city, as well as the words pronounced in his favor by illustrious men-of-letters and artists. First among these was Leon Battista Alberti who, in the preface to his *De pictura*, written in 1436, did not hesitate to mention Luca — with whom he probably got acquainted during his stay in Florence in 1434 — in the same breath as such artistic innovators as Brunelleschi, Donatello, Masaccio, and Ghiberti. That the inclusion of Luca in Alberti's treatise was no accident but reflected its author's full support for the sculptor's esthetic choices is demonstrated by Alberti's open condemnation of Donatello's figures as "without grace and charm." This underscores the preference shown in Albertian circles for the classical equilibrium of Luca which, translated into moral terms, signified "dominion of the passions, studious serenity, *aurea mediocritas*" (Argan, 1968), just as it did in the artist's own life.

Vasari's claim that Luca della Robbia received his training in the goldsmithery of Leonardo di ser Giovanni — who was responsible along with Francesco di Niccolò for the silver altar of San Iacopo in Pistoia and, along with Betti di Geri, for the one in the Baptistry (Museo dell'Opera del Duomo, Florence) — has to be rejected for chronological reasons. As a result we have no clear picture of the artist's training and youthful activity, and he is sometimes seen as having been under the wing of Ghiberti, at others under that of Michelozzo and Nanni di Banco. The preponderant role played by Brunelleschi and the influence of Donatello on the young Luca have been underlined in the recent research carried out by Bellosi (1981) and Gentilini (1982-1983; 1990).

What we do know is that in 1431, at the time of his official appearance on the Florentine artistic scene with the *Cantoria*, Luca della Robbia was already a mature artist, over thirty years old. An artist who showed not only that he was familiar with the models of antiquity he had studied at the Camposanto in Pisa or even, as has been suggested elsewhere (Seymour, 1962-1963; Brunetti, 1973; Pope Hennessy, 1980), through a journey made to Rome in quest of ruins and antiquities around 1429-1430, as Brunelleschi and Donatello had done before him, but also that he had already tried his hand at the new ideas of contemporary art. In this way, Luca combined the naturalism of Ghiberti with the foreshadowings of classicism in the work of Nanni and Michelozzo, along with touches of an advanced realism that do not exclude the influence of Donatello.

The *Cantoria* is the name given to the marble organ gallery that was once located above the Old Sacristy of the Cathedral, opposite the one by Donatello (both were removed in 1688 and replaced by the Baroque pulpits realized for the wedding of Ferdinando dei Medici, the son of Grand Duke Cosimo III, to Violante Beatrice of Bavaria). Since 1889 it has been in the Museo dell'Opera del Duomo, apart from a few architectural parts that have been lost and two *Candelabrum-bearing Angels* made out of gilded bronze that critics have identified with the two smiling and chubby putti in the Musée Jacquemart André in Paris. Throughout the century, it represented the fundamental work of reference for all those who, like Desiderio da Settignano, Mino da Fiesole, and the Rossellino brothers, followed in the footsteps of Luca's moderate plasticism. The work on the *Cantoria* occupied the artist for about eight years. On 28 August 1438 he received the final sum of money due to him: "To Luca di Simone di Marcho della Robbia, stonecutter, XIII flor. s. VIII in gold, which money is given for the rest of the carving of the pulpit of marble that is set in the wall of the main church above the door of the Sacristy leading to the Servites."

Faced with the task of translating into three-dimensional images the 150th and last Psalm of David (*Laudate Dominum*), whose verses are transcribed in elegant Roman lettering on the three fascias of the pul-

18

16. Luca della Robbia
Deliverance of Saint Peter from Prison
69x78 cm
Florence, Museo Nazionale del Bargello

17. Luca della Robbia
Crucifixion of Saint Peter
69x78 cm
Florence, Museo Nazionale del Bargello

18, 19. Luca della Robbia
The Peretola Tabernacle and detail
260x122 cm
Peretola (Florence), Church of Santa Maria

pit, Luca della Robbia set ten bas-reliefs in two superimposed rows, depicting young men, young girls, and putti. Sometimes standing out from and sometimes closely adhering to the background, in order to create a greater impression of depth, the figures are singing in harmony, playing instruments, and dancing. Each

of them, lifted by the artist for a moment from the life of the city to serve as a model for his *Cantoria*, is represented in a confidential style that is reminiscent, in some ways, of the urchinlike putti in Lippi's altarpieces, and is portrayed in a pose, an attitude of his or her own. Yet the figures remain subject to the principle of the overall balance of the scene and help to achieve variety in unity, a vividness and animation within the harmonious serenity of the whole. The realism of his work is clear right from the first reliefs that he carved, the ones at the ends depicting *Boys Singing from a Scroll* and *Boys Singing from a Choir-Book*, which the documents inform us were complete in 1434.

Let us linger for a moment in front of the "swelling of the singers' throats," as Vasari put it, and in particular the slightly larger figure at the center of the second of the aforementioned panels. Note the frown and the wrinkled brow of his companion on the right, struggling to make his praises of the Lord heard above the din of the flutes, trumpets, and psalteries. Then look at the left foot of the smallest singer in front, lifted to mark time and echoed by the clapping hands of the furthest of his friends.

Although the final result that Luca achieved was substantially different from the one that Donatello was striving for in the *Cantoria* opposite, with its joyful and un-

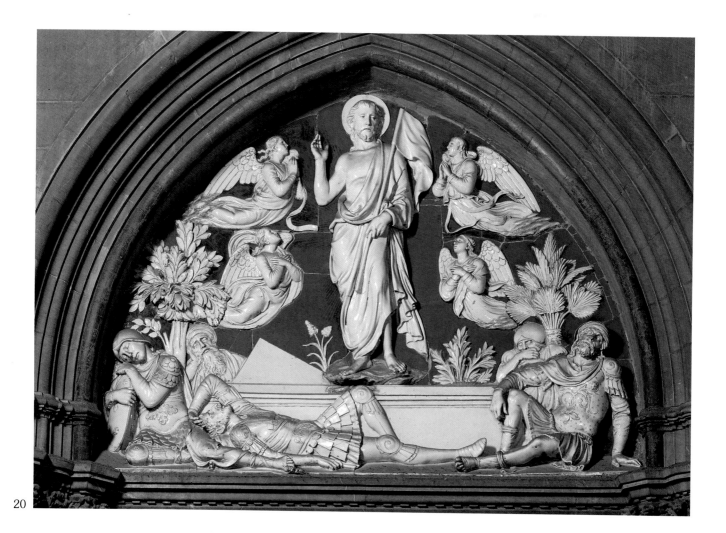

20

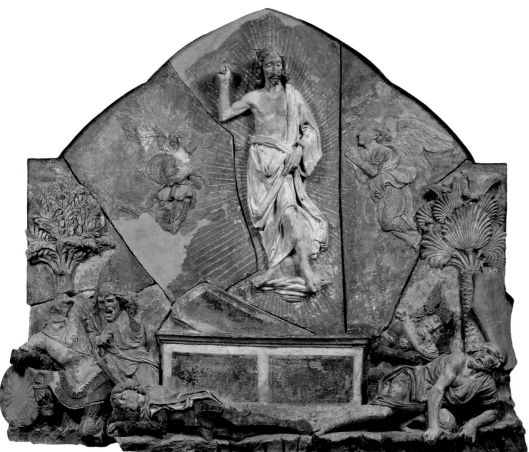

21

20. Luca della
Robbia
Resurrection of
Christ
200x260 cm
Florence,
Cathedral

21. Andrea
Verrocchio
Resurrection of
Christ
Florence, Museo
Nazionale del
Bargello

22. Luca della
Robbia
Ascension
200x260 cm
Florence,
Cathedral

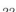

restrained dance of youths who are singing and playing freely against a luminous and atmospheric background of gold mosaic, it will come as no surprise that the artist was not immune to the influence of Donatello's new and original style. In fact the passage from the first reliefs of the *Cantoria* to the later ones reveals a greater stylistic maturity, which finds expression in a new depth of space and liveliness of narrative, a change that can be amply explained by the inspiration provided by the *Cantoria* opposite and by Donatello's *Pulpit* in Prato (1435-1437).

Luca della Robbia's *Cantoria* earned him considerable approval and support; so much so that the Cathedral Vestry Board was not long in offering him new and important commissions.

In 1434 he was asked to collaborate with Donatello on the model of *unam testam terra* for the keystone of the dome. Three years later he was given the job of completing the external decoration of the Campanile, commenced a century earlier by Andrea Pisano. In 1439 he received a commission for two altars for the Tribune of San Zanobi in the Cathedral. In 1442 and 1446 two lunettes representing the *Resurrection* and the *Ascension* were ordered from him, along with the bronze doors of the Cathedral Sacristy (Sagrestia delle Messe) in 1445, which he was commissioned to execute in collaboration with Michelozzo and Maso di Bartolomeo.

Lastly, in 1448, he was asked to sculpt the two *Candelabrum-bearing Angels* for the Communion Chapel.

In the five hexagonal panels for the north side of the Campanile depicting the *Liberal Arts* (*Grammar*, *Logic*, *Music*, *Arithmetic*, and *Geometry*, Museo dell'Opera del Duomo, Florence), Luca managed to remain as faithful as possible to the fourteenth-century tradition of the preexisting reliefs while still making references to the work of Jacopo della Quercia in the undulating planes of the *Orpheus* portrayed in the *Music*, or that of Michelozzo in the neat architecture that serves as a backdrop to the *Grammar*. The terse dialogue that prevails in the *Philosophy* (or *Logic*), in which, according to Vasari, the sculptor portrayed Plato and Aristotle, reminds one of Donatello. The most direct reference to the latter can be seen in the figures of the *Apostles* on the bronze doors of the Old Sacristy of San Lorenzo, but what results in animation, in an unbridled liveliness, in Donatello's work is transformed by Luca's hands into a vibrant but still classical harmony of attitudes and robes.

The *Deliverance of Saint Peter from Prison* and his *Crucifixion* are all that remains of two marble altars that the Cathedral Vestry Board ordered from Luca in April 1439 for the Tribune of San Zanobi, passing on to him a commission that had previously been given to Donatello. We do not know the reasons behind the

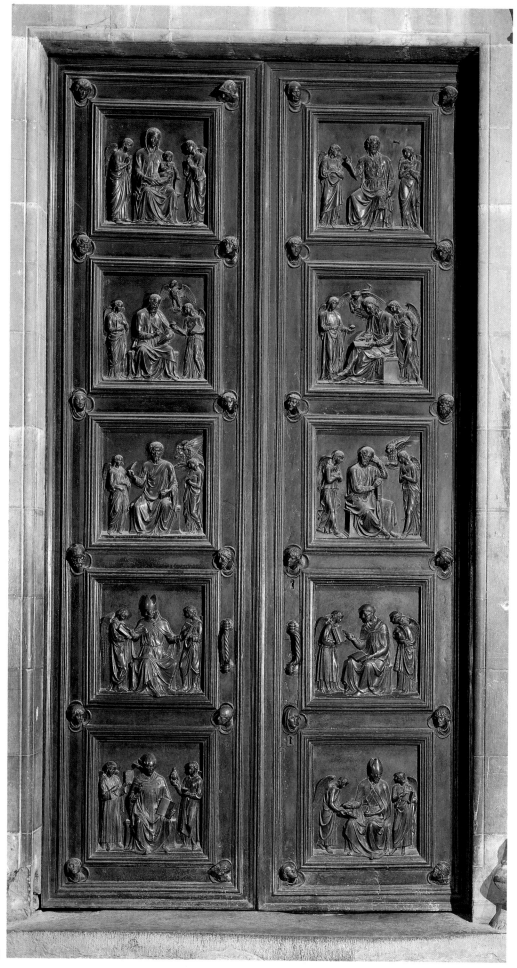

23

choice of Luca or the circumstances that prevented the completion of the work. What is certain is that the two bas-reliefs clearly reveal the influence of Masaccio, especially in the solid and uncompromising corporeity of the figures, reminiscent of the humanity of the latter's work in the church of Santa Maria del Carmine in Florence, and, in the scene of the *Crucifixion of Saint Peter*, in the layout of the composition, based on the predella of the *Polyptych* that Masaccio painted in 1426-1427 for the Carmelite church in Pisa (Staatliche Museen, Berlin).

With the *Peretola Tabernacle* in the church of Santa Maria, executed by Luca della Robbia from 1441 to 1443 for the Chapel of San Luca in the church of Sant'Egidio, adjoining the hospital of Santa Maria Nuova, we come to the first documented work in which the sculptor used, along with marble and bronze, applications of glazed terracotta. Luca was to go down in history as the inventor of the new technique. It is used along the trabeation in the cherubs and the multicolored garlands, in the blue wall that forms the background of the lunette representing the *Pietà*, and in the flat ornament with rosettes and a crutch, emblem of the aforementioned hospital, on the pedestal. While in this work glazed terracotta is still used timidly as a chromatic and decorative embellishment, it is in the *Resurrection* and *Ascension* in the Cathedral that it attains the status of a unique technique and means of expression.

In the lunette depicting the *Resurrection* on the doors of the New Sacristy (Sagrestia delle Messe), commissioned from Luca della Robbia on 21 July 1442, echoes of Ghiberti's approach to composition, such as the motif of the flying angels alongside the risen Christ, are associated with a quest for elegance and preciosity of decoration. The work has an atmosphere of mystical tranquillity that has nothing in common with the nervous dynamism of the *Resurrection* modeled in painted terracotta by Verrocchio about twenty years later for the Medicean villa of Careggi, in which the example set by Luca seems to have been dismissed and its place taken by a new vehemence and vigor.

During the time that passed between the *Resurrection* and the *Ascension*, the latter realized by the sculptor in 1446-1451 for the door of the Old Sacristy or Sagrestia dei Canonici — a period that saw the death of Brunelleschi (1446) as well as Donatello's stay in Padua (ca. 1443-1453) — Luca underwent a process of maturation in which he shifted from a still extremely abstract and sculptural style to a mode of composition that is more concerned with the pictorial and naturalistic possibilities of the subject. The clients themselves played a part in this, stating in writing in the commission their desire for the setting of the scene (mountain and trees) to be rendered in natural colors (*quod mons sit sui coloris arbores etiam sui coloris*).

That sculpture in glazed terracotta had no real rivals in the field of the monumental plastic arts in the middle of the Quattrocento is demonstrated by the ever

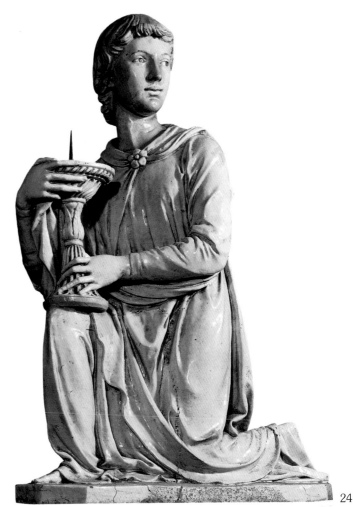

24

23. Luca della Robbia, Michelozzo and Maso di Bartolomeo
The Bronze Doors of the New Sacristy
Florence, Cathedral

24. Luca della Robbia
Candelabrum-Bearing Angel
84x57 cm
Florence, Cathedral

greater quantity of commissions entrusted to Luca della Robbia, such as the two *Candelabrum-bearing Angels* in white glazed terracotta that the Cathedral Vestry Board ordered from him in 1448 for the altar of the Communion Chapel. The robust sculptural quality of the two kneeling youths, originally gilded or painted and equipped with wooden wings, and the rhythmic fluidity and polish of the outlines had an influence on the young Michelangelo, at the time when he was preparing his marble *Candelabrum-bearing Angel* for the Tomb of St. Dominic in Bologna.

The decoration of Brunelleschi's Pazzi Chapel, founded by Andrea dei Pazzi in 1429 as the chapterhouse in the first cloister of Santa Croce, represents the central episode in Luca's fruitful career. The twelve medallions depicting the classical figures of the *Apos-*

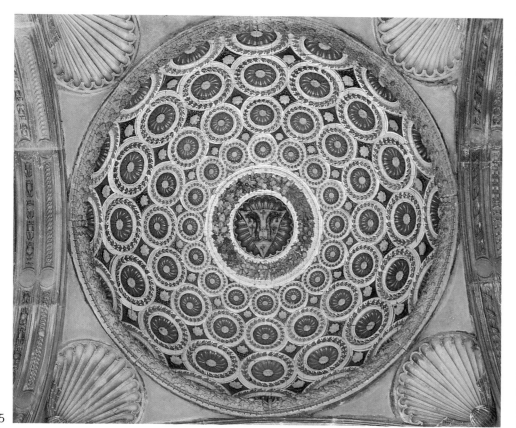

*25. Luca della Robbia
Cupola of the Portico
Florence, Church of
Santa Croce, Pazzi
Chapel*

*26. Interior of the Pazzi
Chapel
Florence, Church of
Santa Croce*

tles in white on a blue ground, in whose design Brunelleschi himself must have played a part, are well suited to the sober and essential lines of the architecture and to the general two-color scheme of the gray *pietra serena* on white walls and vaults. The sense of Olympian serenity that is imparted by these figures — and the *Saint Andrew*, patron of the Chapel, portrayed seated with a book and cross in the classical pose of a pagan divinity, is no exception — was bound to be to the liking of all those in the city who, like Michelozzo and Brunelleschi himself, wanted the decoration to be an integral part, in its intent and in its results, of the architectural complex rather than an extraneous addition.

The decoration of the Chapel was completed with the application of polychrome glazed terracotta representations of the four *Evangelists* in the pendentives of the cupola — it is still a matter of debate whether they are the work of Luca (Bode, 1889; Reymond, 1897), Brunelleschi (Liphart in Burckhardt-Bode, 1884), Donatello (Pope Hennessy, 1977), or an unknown sculptor from the studio of Andrea della Robbia (Janson, 1973) — and with rosettes with bean-shaped decorations arranged symmetrically in concentric tondi around the *Pazzi Coat of Arms*, in the small cupola of the portico.

By the middle of the fifteenth century Luca della Robbia was the most sought-after decorator of interiors in the city. Around 1448, on a commission from his patron and admirer Piero dei Medici, he covered the ceiling of Michelozzo's Chapel of the Crucified Christ, in the middle of the nave of San Miniato al Monte, with

hexagonal panels and glazed rosettes in relief. In 1461 he was given the job of decorating the cupola of the Chapel of the Cardinal of Portugal, Jacob of Lusitania, in the same church: working side by side with Baldovinetti, Pollaiolo, and Rossellino, he set the *Dove of the Holy Spirit* at the center, surrounded by seven candelabra, and the *Cardinal Virtues* (*Fortitude, Temperance, Prudence*, and *Justice*) at the sides, against a background of reversible cubes whose yellows, greens, and purples bring the delicate white figures to life.

Perhaps the most unusual of Luca della Robbia's decorative works are the glazed tondi depicting the *Labors of the Months* in the Victoria and Albert Museum in London, which once decorated the ceiling of Piero dei Medici's study in the Palazzo Medici on via Larga. The refined owner of this study, a forerunner of the bourgeois private collector, used it to house, alongside his collection of books, such precious objects as gems, medals, small bronzes, and vases of chalcedony and alabaster. We are told by Filarete that he took great delight "in examining and discussing their virtues and value." Indeed the first person to mention the tondi was Filarete himself, who made his last recorded visit to Florence in 1456. In his celebrated *Trattato d'Architettura* (1464), Filarete described the room as follows: "a very ornate little study; the floor and also the ceiling, with glazed [decorations] in the shape of exquisite figures so that whoever enters, feels great admiration. The author of these glazed [decorations] was one by the name of Luca della Robbia, a very worthy artist in this glazed [terracotta] and an able sculptor as well."

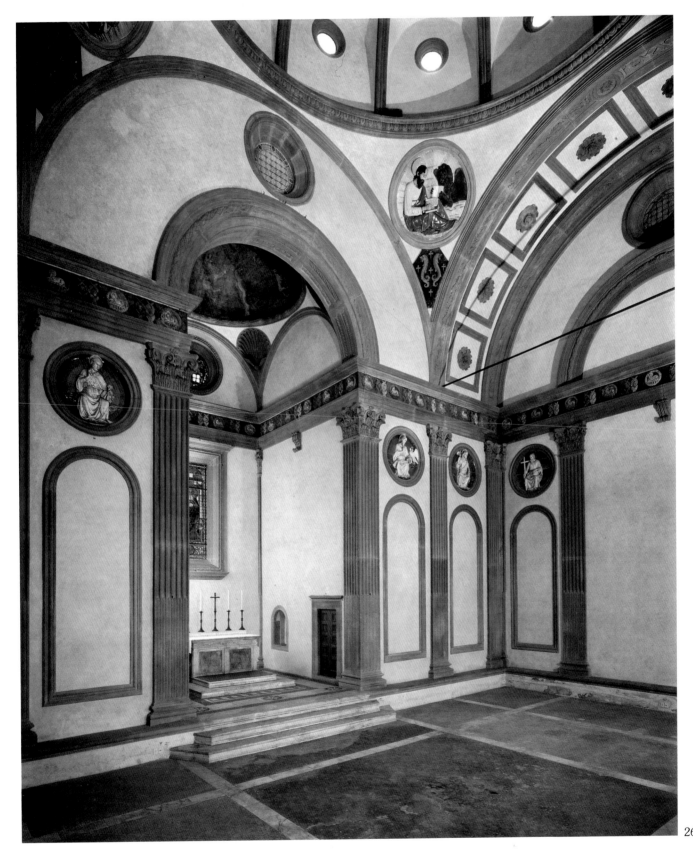

26

The flooring — of which no trace remains but which was mentioned by Vasari in 1568 — was in all probability decorated in a similar fashion with glazed tiles.

Their slightly concave shape suggests that the tondi, whose original conception Salmi ascribes to Domenico Veneziano (Salmi, 1936), were arranged in three rows and linked by architectural moldings, so that they fit-ted the curved surface of the ceiling. As for the iconography, in which the agricultural labors of the months are combined with the respective signs of the zodiac and the hours of the day and night to symbolize the close ties between cosmology and human activity, it is likely that the sculptor drew on some northern European manuscript in the large collection of books belonging

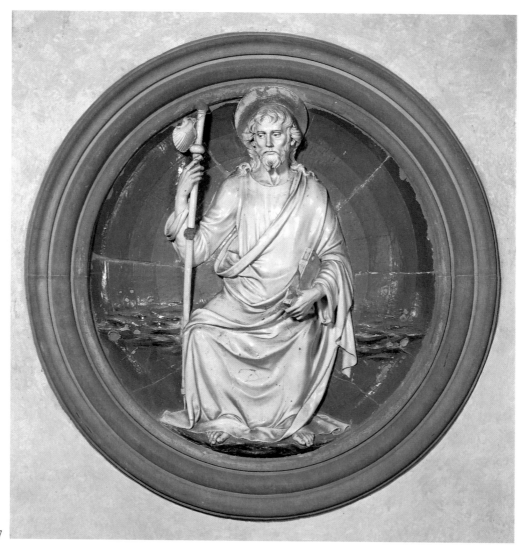

27

27. Luca della Robbia
Saint James the Great
diam. 134 cm
Florence, Church of Santa Croce, Pazzi Chapel

to Cosimo's son, or on such classical texts as Columella's *De Re Rustica*, which had been rediscovered by Bracciolini (Pope Hennessy, 1980).

It is from the years immediately following his intervention in Michelozzo's Palazzo Medici that dates the *Sepulchral Monument of Benozzo Federighi*, bishop of Fiesole, which was commissioned from Luca in 1453 for the patronal chapel in San Pancrazio and then, in 1894, was transferred, without its original plinth, to the church of Santa Trinita. The form of the plinth can be reconstructed from the drawing of it in Baldovinetti's Burial Register (Biblioteca Riccardiana, Fondo Moreni, Florence).

Apart from the reference to Ghiberti in the motif of two angels holding a garland, taken from the *Urn of the Holy Martyrs* (Bargello, Florence), and the perfect modeling of the dead man laid out on the sarcophagus, of the Christ in the tomb, and of the Virgin and St. John in the panels on the rear wall — the most interesting feature, something completely new in funerary art, is the festoon of plants made out of tesserae of majolica on a gold ground that frames the monument. It is a decorous and orderly sequence of bunches of palm leaves, rosettes, myrtles, lilies, roses, pome-

granates; a range of varieties and tones of color that, as a whole, shows signs of Oriental influence, perhaps of Iranian-Ottoman derivation, as was pointed out by Del Bravo (1973).

Luca della Robbia's intervention in the collegiate church of Santa Maria at Impruneta (in whose parish the artist possessed a small farm), involving the decoration of Michelozzo's Chapels of the Virgin and of the Cross (ca. 1448-1470), can be explained by the esteem in which Luca was held in the Neoplatonic circle of Piero dei Medici — a circle of which Antonio degli Agli, rector of the parish church of Impruneta and bishop of Fiesole, Ragusa, and Volterra, was a member.

For the Chapel of the Virgin, built to house the miraculous image of the Virgin that was traditionally held to have been painted by Luke the Evangelist, the artist executed in 1450-1455 the two saints (*Luke* and *Paul*) at the sides, the rosettes with bean-shaped decorations

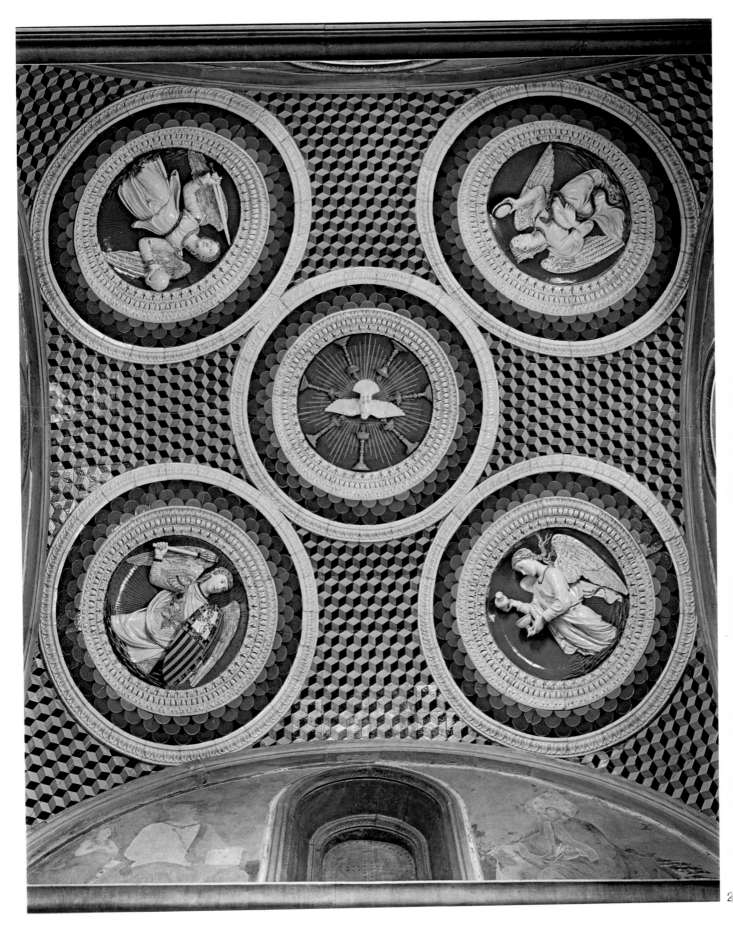

28. Luca della Robbia
Ceiling Decoration of the Portugal Chapel
Florence, Church of San Miniato al Monte

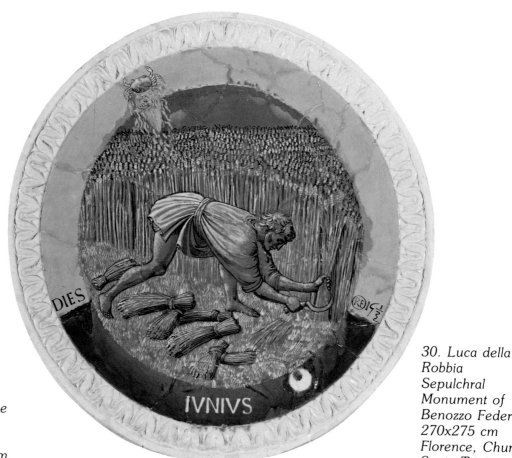

DIES

IVNIVS

29. Luca della
Robbia
The Month of June
diam. 57 cm
London, Victoria
and Albert Museum

30. Luca della
Robbia
*Sepulchral
Monument of
Benozzo Federighi*
270x275 cm
Florence, Church of
Santa Trinita

on the ceiling, and the frieze of plants on the trabeation, interspersed by two reliefs representing the *Madonna and Child*. The decoration of the Chapel of the Cross, housing a piece of the wood of the True Cross, dates from a later period: at the sides are *Saint John the Baptist* and *Saint Augustine*, with the *Crucifixion* (ca. 1465) in the middle. The latter work was to influence Andrea della Robbia in his own version of the *Crucifixion* in La Verna. Here the perfect modeling of Christ — the bowed head, the rigid and tense members of the body signifying the drama of the living and suffering man — between the Virgin, St. John, and two weeping angels reveals the influence — as Pope Hennessy has already pointed out (1980) — of Brunelleschi's wooden *Christ Crucified* in Santa Maria Novella. The *Madonna and Child* in the frieze portrays the Child lying with his arms and head resting tenderly on the breast of his mother. The Madonna's face, of classical beauty, betrays her feelings of anxiety and maternal apprehension over the uncertain fate of her Son.

This brings us to the fascinating world of Luca della Robbia's images of the Virgin Mary, a world of intimacy and motherly tenderness portrayed under milky skies filled with luminous matter. Especially popular in religious circles, they were also appreciated for their qualities of brilliance and whiteness, alluding to purity and spiritual light, in the climate of rampant Neoplatonism in the mold of Marsilio Ficino that held sway in Florence in mid century. Examples of this are provided by

the two versions of the *Madonna della Mela* (*Madonna of the Apple*, 1455-1460) in the Bargello, in which the thoughtful mien of the Virgin is contrasted by the lively and greedy expression of the Child, who is holding the round fruit jealously in his hands. Then there is the *Madonna del Roseto* (*Madonna in a Rose-Garden*, 1450-1455; Bargello, Florence), which, set in a flower garden with the Child in the act of turning to pluck a small white rose from the hedge, should be considered, along with the *Frescobaldi Madonna* (formerly in Berlin, lost), an anticipation of della Robbia's scenic altarpieces, as was pointed out by Gentilini (1982-1983). The *Madonna and Child* in the Museo dello Spedale degli Innocenti, Florence (1445-1450), is typologically akin to the *Altmann Madonna* in the Metropolitan Museum of New York, with the Child holding a scroll in front of himself that bears the inscription *Ego sum lux mundi*, the same words as appear in the lunette in Urbino.

The *Madonna and Child between Saints Dominic, Thomas of Aquinas, Albertus Magnus, and Peter the Martyr*, executed by Luca della Robbia in the years 1449-1451 for the portal of the church of San Domenico in Urbino, is the only work that the artist is known to have carried out outside Florence. Here we find the balanced composition and carefully studied correspondences of form typical of Luca. The Child is the central axis of the composition, partly by virtue of that little foot pushed forward as if to suggest, figuratively, the center.

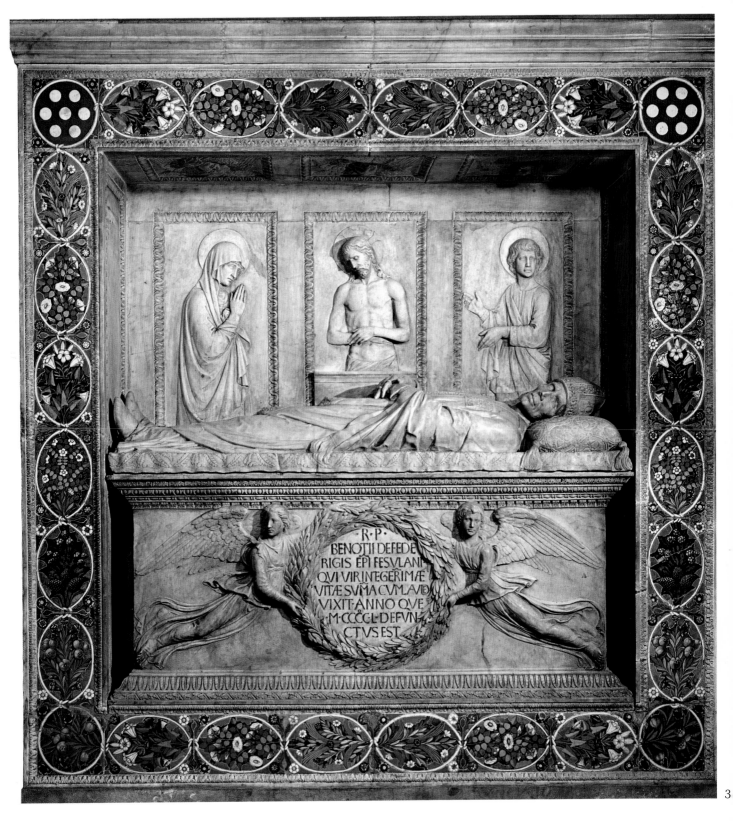

As Longhi pointed out (1927), it is likely that the lunette in San Domenico was an important influence on the development of the young Raphael in Urbino.

The Madonna and Child Enthroned between Two Adoring Angels, in the first panel on the left of the bronze doors of the Old Sacristy in the Cathedral, ordered from Luca in 1446 in collaboration with Michelozzo and Maso di Bartolomeo, is related, in the modeling of the central group, to the *Madonna del Roseto*, while the angels retain, in their graphic modeling, echoes of Ghiberti, as do the small protuberant heads of *Prophets* set along the molding, drawn from Ghiberti's two doors for the Baptistry. Evidence for the fact that the two-color scheme used in Luca's terracottas was merely a response to the preference shown for it in the Neoplatonic and religious milieu of the city, owing to its qualities of purity and candor, is provided by the *Coat of Arms of the Doctors' and Apothecaries'*

31

32

*31, 32. Details from the Border of the Benozzo
Federighi Monument
Florence, Church of Santa Trinita*

*33. Luca della Robbia
Madonna and Child
Impruneta, Church of Santa Maria*

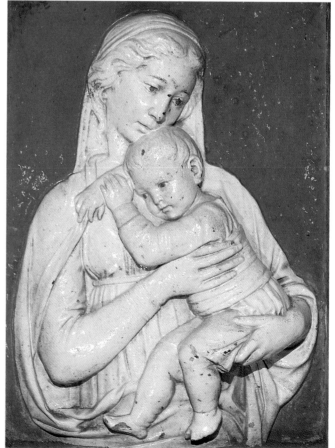

33

Guild in Orsanmichele (1455-1460). Here Luca did not hesitate to use vivid tones for the central group of the Madonna and Child, set in a niche, using color for the hair and faces as well.

One of the most fascinating aspects of Renaissance art is the genre of portraiture. The Bargello has two portraits of women by Luca della Robbia that are of extraordinary beauty and quality. We do not know who the *Portrait of a Young Lady* in a tondo (1465-1470) is supposed to represent, but it is very likely that she was a girl from the Florentine aristocracy of the time (perhaps a lady from the house of the Medici) as is suggested by the extreme fineness of her features, reminiscent of the delicate female figures portrayed by Desiderio da Settignano or by Antonio del Pollaiolo (cf. the *Lady*, 1480, Museo Poldi-Pezzoli, Milan).

Here Luca's genius is apparent in the distinctness of the image, in the execution of a synthetic work in which the portrait seems to be sealed in by its sharp outlines,

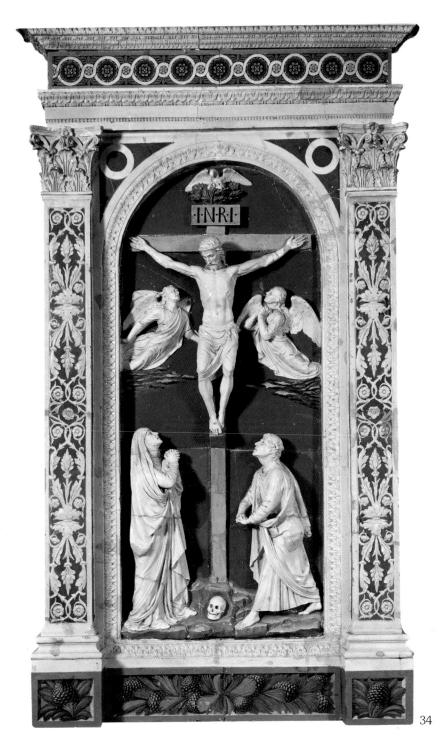

34. Luca della Robbia
Crucifixion
150x65 cm
Impruneta,
Church of Santa
Maria

34

but without taking anything away from the detail and the very human intimacy of the person portrayed.

Let us pause for a moment to examine the perfect oval of that face, framed — according to the fashion of the time — by a voile bonnet with a double string of pearls on the forehead and two tufts of feathers hanging down at the sides, clasped in the middle by a brooch studded with gems and pearls. Around her neck hangs a pearl necklace with a jewel. Characteristic are the hairstyle, with the hair gathered at the nape, the convex forehead, made artificially high by depilation (as was the style during the Renaissance), and the use of pearls, which were preferred to other ornaments at the time not only for their magic powers but also because they never lost their value.

In the will he drew up on 19 February 1471 in the refectory of the monastery of San Marco, Luca della Robbia left the control of his studio in the hands of the son of his brother Marco, Andrea della Robbia. On the death of his uncle in 1482, Andrea could indeed consider himself fortunate, in charge of an established workshop with a high reputation as a result of the work carried out by Luca and of his specialization in glazed terracotta.

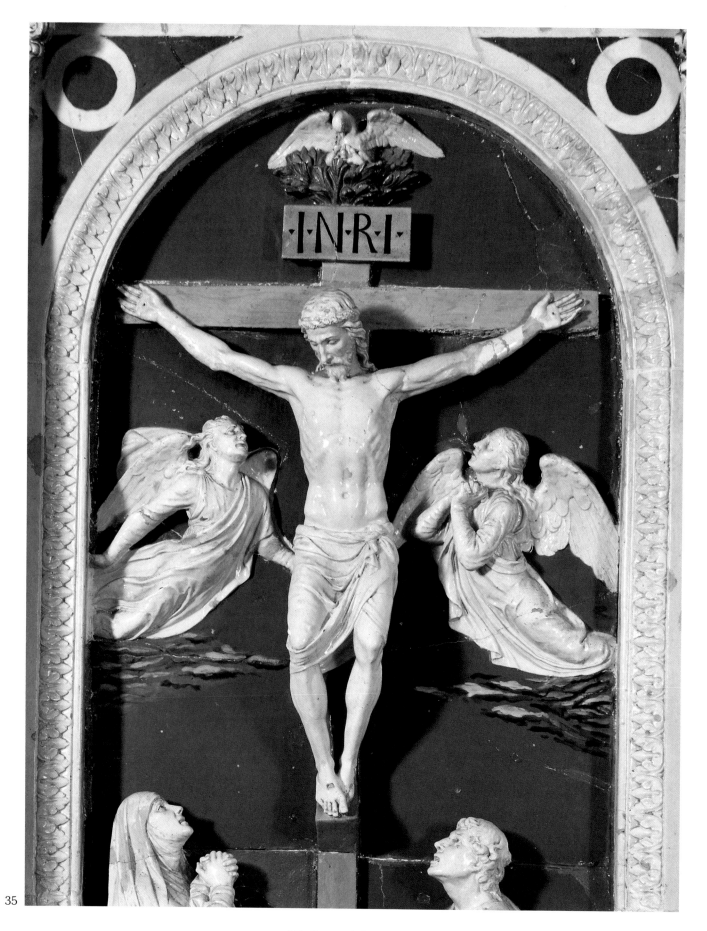

35

35. Luca della Robbia
Crucifixion, detail
Impruneta, Church of Santa Maria

The introduction of glazed terracotta in Florence during the Renaissance: opening of the della Robbia workshop

It was a mere "whim" that earned Luca della Robbia the historical accolade of an inventor and that imbued his art with the incomparable and lasting fascination of the "secret of the della Robbias."

"For," as Vasari explains, "considering that clay was easy to work and required little effort, and that all that was needed was to find a way to preserve works in such a material for a long time, he went on trying out so many whims that he discovered a way to defend them against the ravages of time: for, after having experimented with many things, he found that covering them with a layer of glaze, made out of tin, fired clay, antimony, and other minerals and compounds, fired in a special kiln, achieved this effect very well and made works of clay almost eternal. For which method, of which he was the inventor, he earned great praise and the gratitude of all the centuries that are to come."

So Luca della Robbia's great merit lies in having been the first to apply to the art of terracotta sculpture — revived during the Quattrocento largely as a result of Brunelleschi's and Donatello's willingness to experiment — a purpose-made, clear, tin-based glaze, a process known in Italian as *invetriatura*, that soon turned out to be providential for the preservation of delicate and fragile works molded out of "earth."

The technique of *invetriatura* or glazing was developed by the ancient civilizations of the East, and inherited by the Roman and Byzantine world.

It was then passed on in the fourteenth century, by way of the Arabs, to those regions of Europe dominated by the Moorish culture, and in particular the Spanish island of Majorca or Majolica, which became a center for the trade in crockery, earthenware, and other glazed objects for domestic use of Arab origin. It was not therefore a true invention, as one might be led to believe by Vasari's description, which was uncritically accepted by later sources, from Borghini (1584) to Baldinucci (1681). Rather it was a conscious and deliberate revival on the part of the sculptor of a very ancient technique, now placed at the service of monumental plastic art. As for the "secret par excellence" or "archsecret" as Camesasca called it (1966), its story is well-known: the magic recipe, jealously concealed by the heirs to Luca's studio, was later passed on to Benedetto Buglioni by a char-woman of the della Robbia family. After being written down on a sheet of paper, it was hidden inside the head of a Madonna modeled in "earth"; chance would have it that the sculpture fell and shattered into pieces, and thus the mysterious alchemical formula that it contained was lost.

Although the legend of the mysterious arcanum has now been debunked, since rather than a secret it was actually a speciality of the della Robbia workshop, to the perfecting of which (with increasingly sophisticated and advanced materials and techniques) Andrea della Robbia and his sons and collaborators made a fundamental contribution, we should not underestimate the aura of mystery in which the field of the arts was cloaked during the Renaissance. Even Vasari could not resist giving a detailed description of Andrea del Castagno's plot to murder Domenico Veneziano in order to steal from him the secret of oil painting. Stepping outside the Florentine world, it is known that Pordenone used to paint with a sword by his side to defend himself against anyone who dared to show too much curiosity about certain of his methods. In the field of ceramics, finally, it suffices to recall how in the subtitle of his celebrated treatise *Li tre libri dell'arte del vasaio*, written in the middle of the Cinquecento (before 1559), Cipriano Piccolpasso felt it necessary to explain that in "them not only the practice is dealt with but briefly all the secrets of it" so that "many may know the benefit that a few keep hidden."

So we should not be too surprised if, in a similar context, there was talk of the secret of the della Robbias or of their magic alchemical formulae.

The need to protect the work of art from the action of various atmospheric agents and from the corrosive effect of other factors, not least of them dust, was realized even in antiquity. Pliny the Elder refers to this in his *Naturalis Historia* (1st century A.D.), which had been rediscovered in Medicean circles and translated into Italian by Landino, as is recorded in the inventory of the Medici house's collections drawn up in 1464 and published by Müntz (1888). Pliny mentions the frequent use by Apelles of *atramentum* or "ink", a thin coat of paint that not only gave a brighter sheen to the picture but also helped to preserve the surface of the paint.

29

WILLIAM WOODS UNIVERSITY LIBRARY

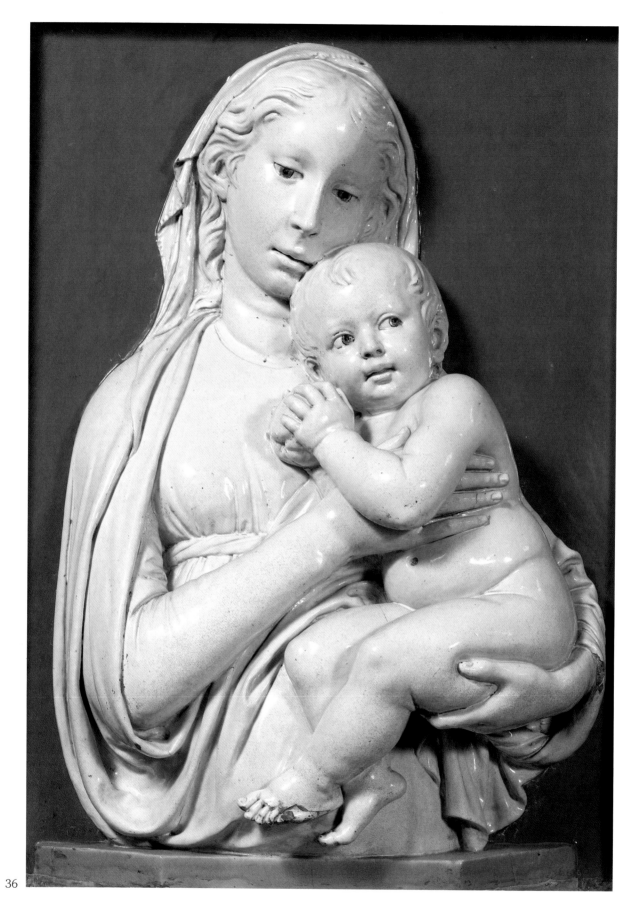

36. Luca della Robbia
"Madonna della Mela"
70x52 cm
Florence, Museo Nazionale del Bargello

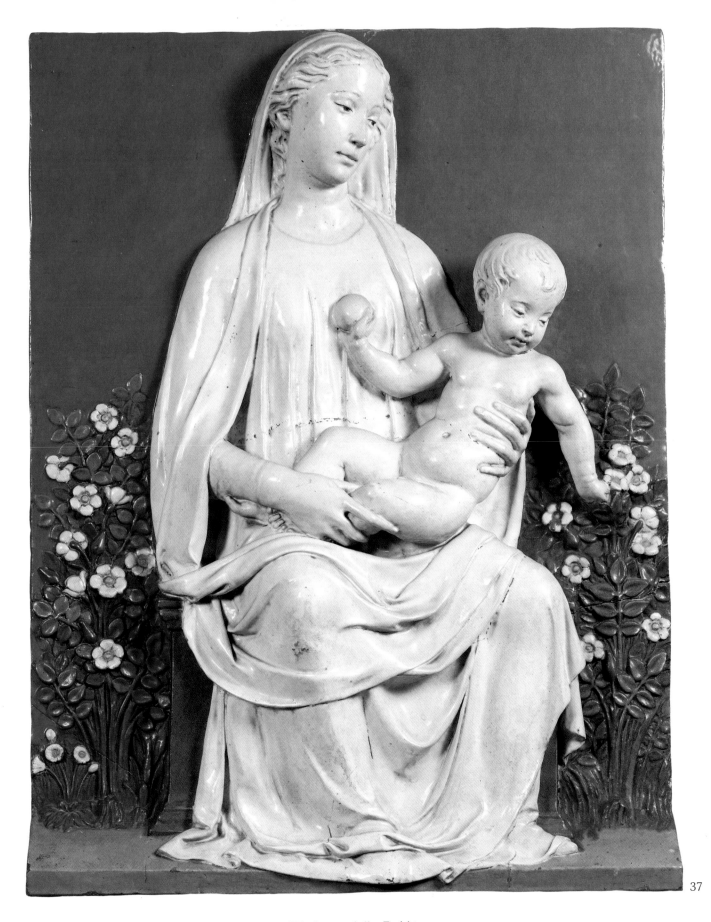

37. Luca della Robbia
"Madonna del Roseto"
83x63 cm
Florence, Museo Nazionale del Bargello

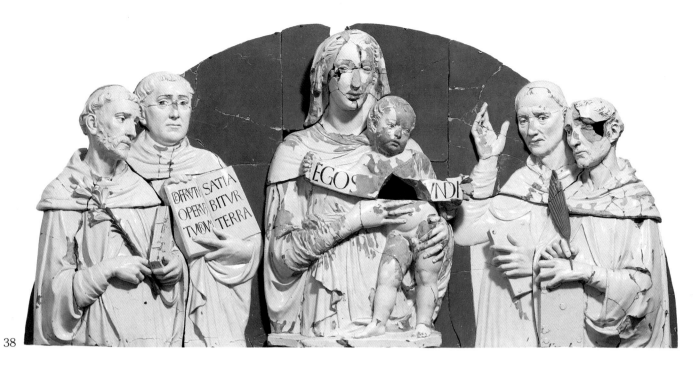

38

38. *Luca della Robbia*
Madonna and Child between Saints Dominic,
Thomas of Aquinas, Albertus Magnus and Peter
the Martyr
111x230 cm
Urbino, Galleria Nazionale delle Marche

39. *Luca della Robbia*
Madonna and Child
75x43 cm
Florence, Museo dello Spedale degli Innocenti

40. *Luca della Robbia*
Coat of Arms of the Doctors' and Apothecaries'
Guild representing the Madonna and Child
diam. 180 cm
Florence, Church of Orsanmichele

The process of glazing, that is the process of rendering the earthenware object impermeable, involved covering it with a transparent glaze known as *cristallina* or *vetrina*, produced by grinding together lead oxide and pure silica and dissolving the mixture in water.

The glaze could be colored by the addition of various natural earths: with cobalt it turned blue, with copper green, with compounds of iron and antimony yellow and brown, and with manganese purple and deep blue; white was obtained by the addition of tin oxide. The various attempts that were made to use colors derived from manganese oxide produced very poor results, as is borne out by the difficulties experienced by everyone from Luca onward in obtaining bright shades of red. The dress of the *Madonna* in the *Coat of Arms of the Doctors and Apothecaries* is a dirty violet that is only remotely reminiscent of the vivid and gaudy red used by painters for Mary's clothing in the pictures of that time. The glazed works of Luca and those executed under his close supervision, in consonance with the esthetic preferences of the Neoplatonic milieu and with the pure and limpid lines of Brunelleschi's architecture, are in the classic della Robbian two-color scheme (white and blue). More variegated color schemes were only permitted in the decorative trimmings, in particular for the dense and pithy garlands of plants, in which green leaves were neatly intertwined with rosettes, lilies, quinces, oranges, and cucumbers, enriching the deliberately limited palette of the central composition.

The greater emphasis on color to be found in later

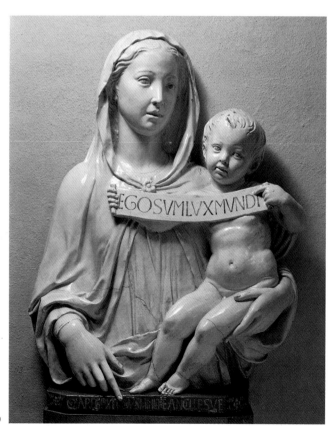

39

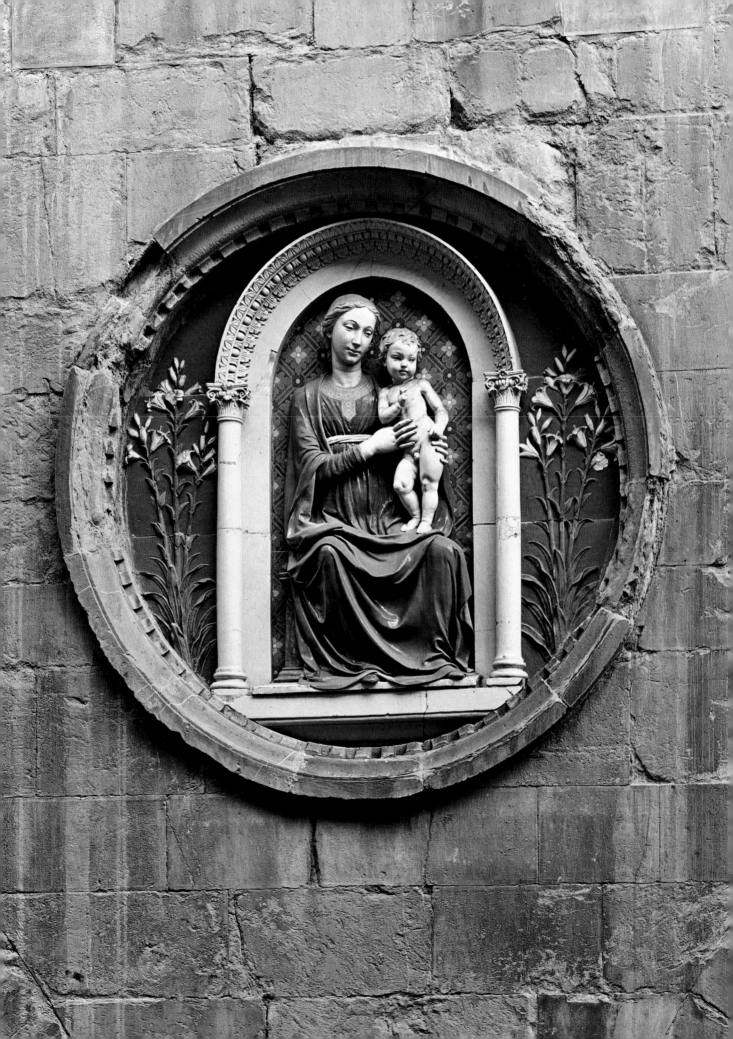

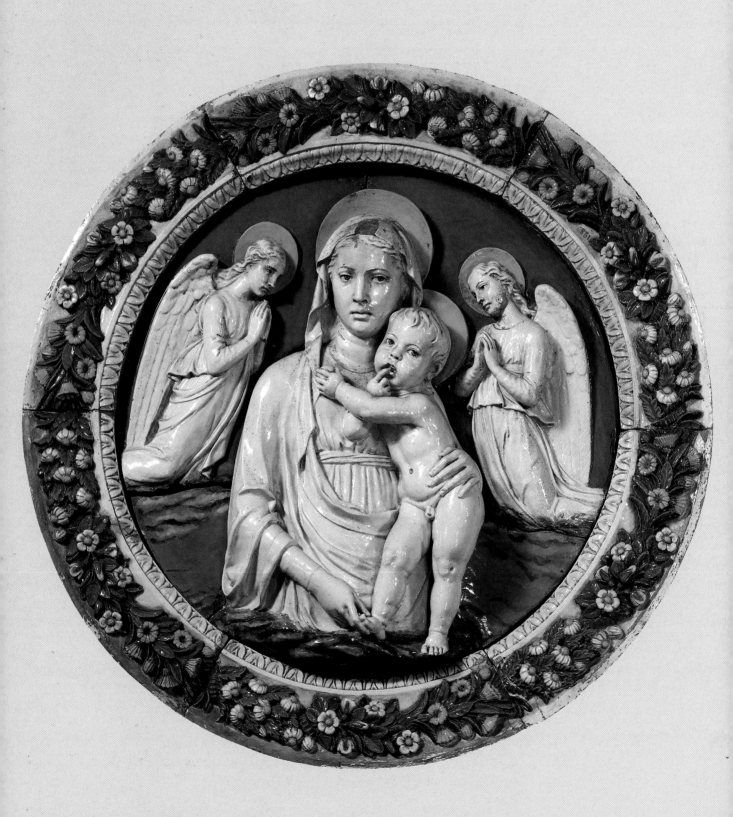

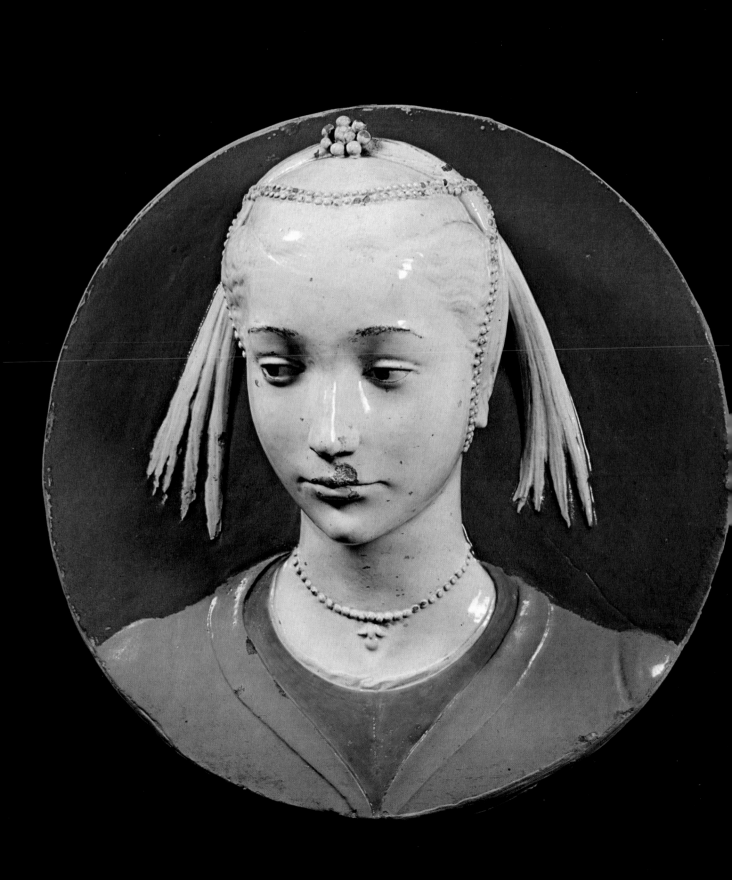

della Robbian production, the work of Andrea but above all of Giovanni della Robbia and the Buglionis, was a consequence of the trend toward a more accentuated naturalism and picturesqueness. At the same time it was an expression of these artists' desire to emulate the painting of their day which, from the end of the Quattrocento onward, with Andrea del Sarto, Fra Bartolomeo, Leonardo, Perugino, and Raphael, was in the forefront of the renewal of artistic forms in Florence.

The documents on the della Robbias published by Marquand (1920) and Pope Hennessy (1980) mention a kiln that was located in the "antekitchen" of the house on via Guelfa that had been in the artist's possession since 1446. In fact Andrea della Robbia's will (1523) contains the following reference: [...] *jn qua anticucina est furnus et truogolj reservato tamen arte victreriarie.*

We must therefore conclude that the majority of works produced in terracotta during the Renaissance came out of via Guelfa, where not only the works of Luca and his successors were fired and glazed, but also those of other artists in the city, like Benedetto da Maiano, Andrea Sansovino, and Giovan Francesco Rustici, who relied on the della Robbia workshop to make sure that their earthenware manufactures received the correct firing and glazing.

While this may have been the case with the *invetriati* produced after the purchase of the house on via Guelfa in 1446, there remains the question of Luca's earlier works, for by that year he had already realized the *Peretola Tabernacle* and the *Resurrection* in the Cathedral, and was preparing to start on the *Ascension.* The lack of documentary evidence places limits on our speculations, but the presence in the city of well-equipped majolica workshops — such as that of Giunta, who in 1431-1432 received an order to supply the famous Florentine hospital of Santa Maria Nuova with a wide range of vessels, or those of the brothers Maso, Miniato, and Piero di Domenico at Ricorboli and of Piero di Mazeo inside Porta Santa Croce — does present the possibility that Luca made use of their facilities for his early experiments with "earth."

We are informed by contemporary treatises on the working of clay that the object was first modeled by the artist in a single piece or, if it was of large dimensions, in several, to avoid the risk of breakage during firing. This was done either by hand or with the help of molds for standardized products. It was then left to dry and subjected to the firing process. The latter, judging by documents from the time, was cloaked in an atmosphere of magic, of almost religious expectation. Once again it is Piccolpasso who tells us: "[...] in the name of Christ Jesus let the firing commence."

For a work in "earth" to turn out well, in fact, a perfect firing is fundamental, without any sudden changes in temperature. For, as Piccolpasso explains: "[...] growing too hot the fire, the works warp and get over fired."

After the first firing (between 750° and 900°C), the article acquires a considerable degree of hardness. This is known as "biscuit" firing. The subsequent phases of firing serve to fix the glazing and coloring of the object. Lead- and tin-based paints are applied to the "biscuit" in the second phase of firing, at about 900°-1000°C. Only a few colors survive such high temperatures, and as a result a third phase is necessary, the so-called "little firing" or "third firing," between 600° and 800°C. To make it possible to check that the temperature was right, the kilns were equipped with small windows, which Piccolpasso informs us were known as *vedette* or "peepholes." After molding, firing, and glazing, the various pieces of the work in terracotta were packed in special numbered crates and sent to the place for which they were intended, where they were reassembled in the manner of a jigsaw puzzle.

As early as 1450 the della Robbias were already delivering their works to distant destinations. There is a record of the despatch on 28 May 1454, as part of a consignment of goods sent from Pisa to Lisbon, of "seven crates of glazed terracotta, property of the marquis of Valencia."

In 1469-1470 Luca della Robbia's workshop delivered the *Sepulchral Monument* of the bishop of Tournai, Guillaume Fillastre, once again by sea from Pisa. The people placed in charge of transporting the work from Florence, first by river to Pisa and then to the port of Ecluse, close to Bruges, were the Florentine merchant Agnolo Tani, Fillastre's secretary and in those years director of the Banco Medici in Bruges, and Tommaso Portinari, who is famous for having commissioned the *Adoration of the Shepherds* or *Portinari Altarpiece* (1475) from Hugo van der Goes for the Florentine church of Sant'Egidio (now in the Uffizi).

Vasari himself could not resist mentioning the fame and repute that Luca della Robbia and his studio acquired outside the city, throughout the Italian peninsula and Europe. "The fame of these works spreading not only through Italy but the whole of Europe, there were so many people that wanted them, that the Florentine merchants kept Luca continually at work, and to his great profit sent them all over the world." And he goes on to say: "And because he could not do it all by himself, he took his brothers Ottaviano and Agostino away from the chisel, and set them to make these works; in which he and they together earned far more, than up until then they had done with the chisel; so that as well as the works that were sent to France and Spain, they produced many other things."

Apart from the mistake that the biographer from Arezzo makes over Luca della Robbia's kinship with Agostino and Ottaviano di Duccio, for which there is no historical foundation, it is undeniable that the sculptor must have relied on a number of assistants, apprentices, and collaborators in the workshop, reserving only the commissions of greater prestige or value for himself. Unfortunately the scarcity of documents makes it difficult to determine the hierarchy in the studio and the names of the various assistants, a problem compounded by the

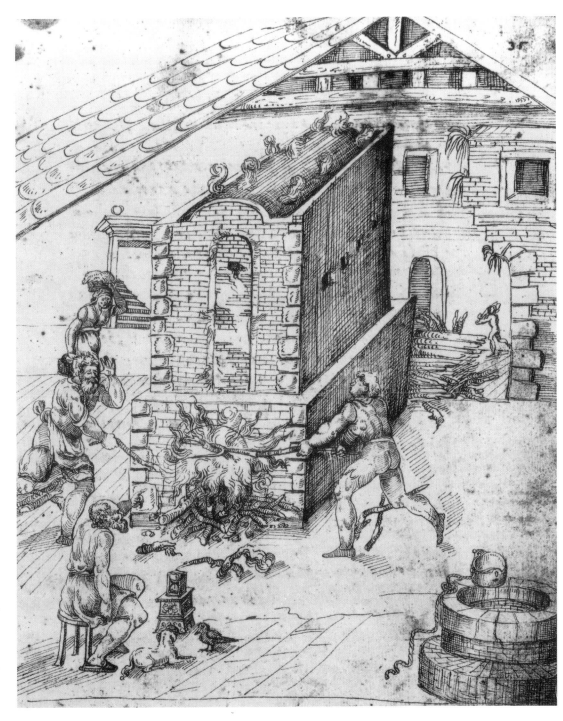

41. Luca della Robbia Madonna and Child between Two Angels ("Madonna delle Cappuccine") diam. 100 cm Florence, Museo Nazionale del Bargello

42. Luca della Robbia Portrait of a Young Lady diam. 45 cm Florence, Museo Nazionale del Bargello

43. Cipriano Piccolpasso 'Putting into the oven and first firing' (from: "Li tre libri dell'arte del vasaio", ante 1559)

43

fact that payments were always made to the master, who was the only person responsible to the client. The situation — as we shall see shortly — became even more tangled under Andrea della Robbia, at a time when the takings of the studio were beating every record and della Robbia ware could be found almost everywhere, proclaiming the success of an artistic phenomenon that has remained synonymous for centuries with Tuscan industry and genius.

"I suppose nothing brings the real air of a Tuscan town so vividly to mind," wrote Walter Pater in the nostalgic climate of the della Robbia revival at the end of the last century, "as those pieces of pale blue and white earthenware, by which he [Luca] is best known, like fragments of the milky sky itself, fallen into the cool streets, and breaking into the darkened churches."

diffusion, beating every record for takings. This was in part due to the workshop's increasingly efficient mass production of "terracottas" and ability to offer its clients a more and more varied and enticing range of products in which everyone could find just what he wanted.

During the early part of his career Andrea realized the *Madonna and Child between Saints Cosmas and Damian* (Oratory of the Arciconfraternità della Misericordia, Florence) for the Sassetti-Doni Chapel in the Badia Fiesolana. It was ordered by Francesco Sassetti, a well-known Florentine merchant who was the confidant and right-hand man of Cosimo and Piero dei Medici and a sympathizer with the Neoplatonic culture along the lines established by Ficino that was favored by Medicean circles — a culture that had a considerable influence on the production of the della Robbias in the seventh decade of the century. It is one of Andrea's first altarpieces, dating from around 1466, in which the division of the main scene into three in the early della Robbia altarpieces — such as can be seen in the Pescia altar or in that of Santa Maria degli Angeli in Assisi — is replaced by a unitary composition, in which the images are enclosed by an architectural framework along strictly classical and Brunelleschian lines. While the essentiality of the central panel, which makes no concessions to mere ornamentation, is evidence of the tendency toward a greater abstraction and purity of form, in vogue during the 1470s, the typology of the Virgin and the other figures and the pleasing narrative vein that runs through the scenes of the predella (from the left: *Annunciation*, *Nativity*, and *Adoration of the Magi*) are new elements that Andrea della Robbia had made his own.

The originality of his language is still more evident in the *Madonna of the Architects* in the Bargello, the oldest documented work by the artist. Realized for the sum of ten florins in 1475 and intended for the meeting room of the Guild of the Stone-Masons and Wood-Carvers, on chiasso de' Baroncelli, the Guild's emblems (plumb-line, ax, hammer, and trowel) appear in the middle of the frame inside tondi in the color of porphyry. The inversion of the central group with respect to the scheme used by Luca, with the Child on the right of the Virgin Mary, is just one of the more tangible signs that Andrea was developing a new artistic identity of his own, deriving from the original model but deviating from it.

While the Child is a reinterpretation, with a more undulatory motion of the limbs that is reminiscent of Verrocchio, of the one represented by Luca in the *Coat of Arms of the Doctors and Apothecaries* in Orsanmichele and in the *Madonna delle Cappuccine* (*Madonna of the Capuchin Nuns*) in the Bargello, the new features include the three-quarters-length portrayal of the Virgin, the iconography of the Father's hands opening to send off the mystic Dove, the halos — as round as Communion wafers — above the heads, and the more intimate and domestic atmosphere of the relief, an effect achieved partly through the vivacious little faces of angels on the inner surface of the frame.

In a period in which, from the seventh decade of the fifteenth century onward, greater emphasis was placed on the educational function of the figurative arts, as a result of the activities of the reformed orders, the production that Andrea della Robbia was developing could not fail to meet with success owing to the ease with which its images could be interpreted. Proof of this is provided by the numerous devotional reliefs by the sculptor and his collaborators that have come down to us. Further evidence is offered by the ever increasing demand for altarpieces in glazed terracotta, a fact that can be explained by the popularity of a product that was more

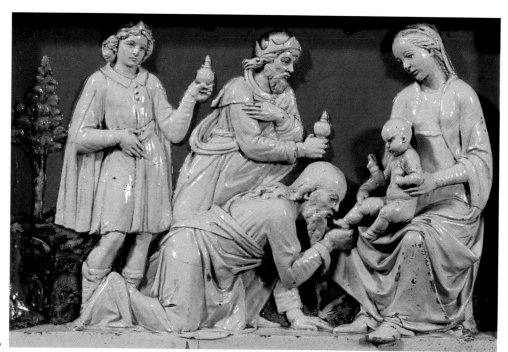

*45, 46. Andrea della Robbia
Madonna and Child between Saints Cosmas and Damian and one of the predella scenes depicting the Adoration of the Magi
217x180 cm
Florence, Arciconfraternita della Misericordia*

45

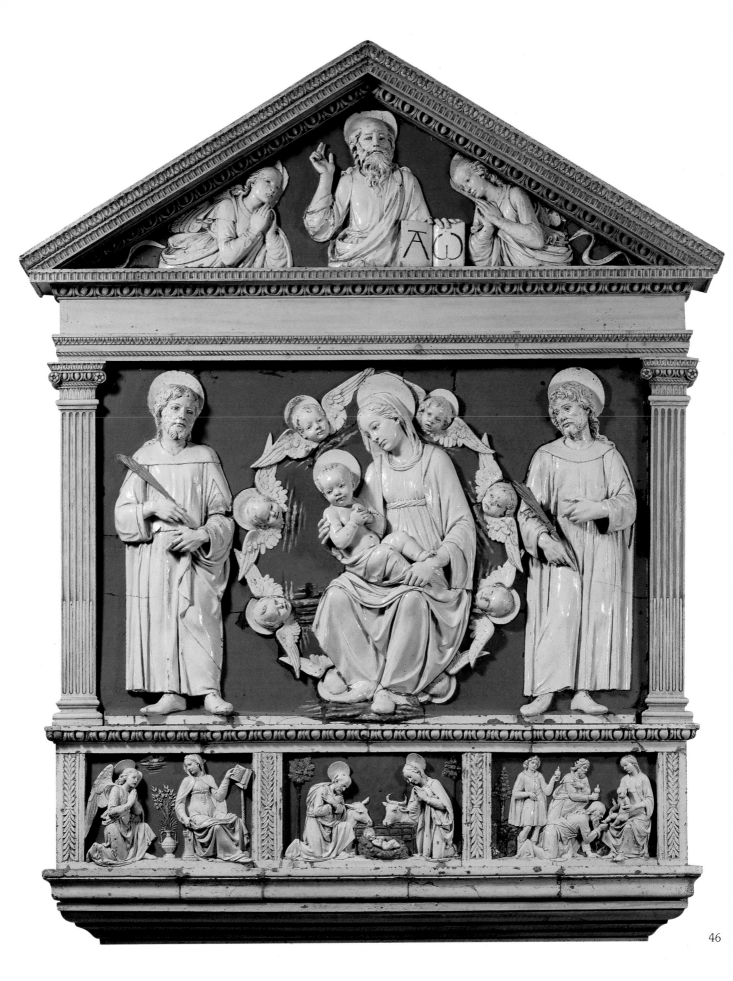

46

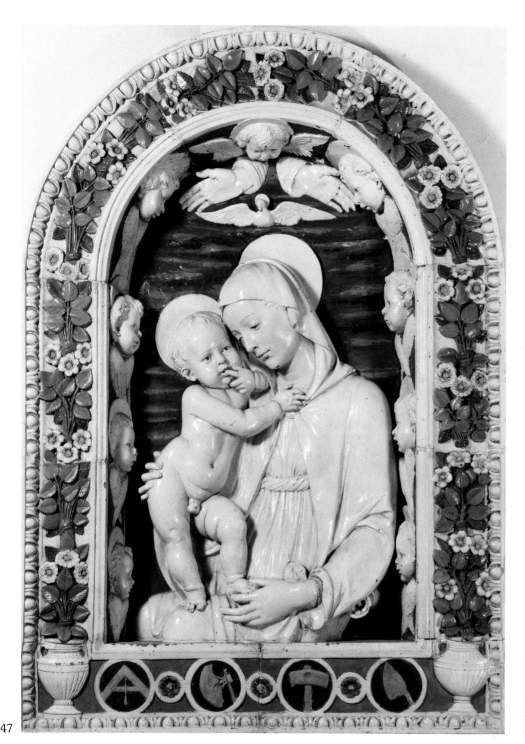

47

47. Andrea della Robbia
Madonna of the
Architects
134x96 cm
Florence, Museo
Nazionale del Bargello

48. Andrea della Robbia
Coronation of the Virgin
265x230 cm
Siena, Chiesa
dell'Osservanza

in tune with the esthetic preferences of the mendicant orders than any other. It was also ideally suited to their plans of disseminating a new *Biblia Pauperum* that would be able to reach even the most inaccessible and remote places, such as the Monte della Verna where, as Vasari tells us, "[...] no painting would have been able to survive even for a very few years."

Around 1474 Pier Paolo Ugurgieri da Siena, provincial vicar of the Franciscan order, commissioned the *Coronation of the Virgin and Saints* from Andrea della Robbia for the patron's chapel in the renovated church of the Observance in Siena, the place where St. Bernardine's reform had got under way. The hinged altar-piece — in which the sculptor represented a favorite theme of Bernardinian iconography that he had already tackled in the *Baglioni Altarpiece* in Santa Maria degli Angeli in Assisi and would return to later in the *Vetusti-Oliva Altarpiece* in San Bernardino in L'Aquila — is framed by an elegant architectural structure classically decorated with palmettes and lotus flowers. These elements were to turn up again in the La Verna altarpieces together with the taste for a measured art, tending toward stasis and sobriety of forms, that would be a mark of Florentine art in the middle of the 1570s, as a reaction to the greater vitality and vigor of expression in the previous decade.

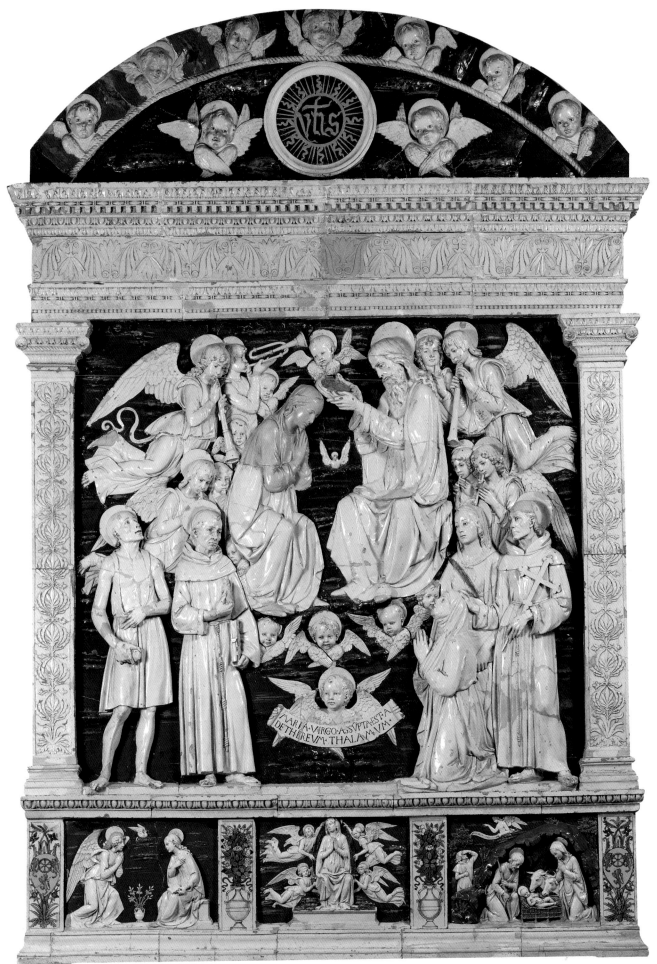

48

The della Robbia cycle on La Verna

Vasari was the first to single out the altars of La Verna as part of Andrea della Robbia's extensive production of glazed terracottas, which played such a pivotal part in the artistic activities of the reformed Franciscans during the second half of the fifteenth century. "Likewise he made many pictures in the church and in other places on the rock of La Vernia, that have been preserved in that deserted place, where no painting would have been able to survive even for a very few years." These were the *Annunciation*, the *Adoration of the Magi*, the *Ascension* with *Saint Francis* and *Saint Anthony Abbot* in a niche, in the upper church, the *Madonna della Cintola* (*Madonna of the Girdle*) in Santa Maria degli Angeli, and the *Crucifixion* in the Chapel of the Stigmata. The other altarpieces on La Verna must be considered the work of the studio.

Thus the great popularity of glazed terracottas among reformed circles at the turn of the century resulted in a more extensive involvement of pupils and assistants in the work. Outstanding among those who contributed to the cycle in the Franciscan monastery of La Verna, was, as we shall see later on, the author of the two side altarpieces in the lower church (the *Nativity* and *Christ in Sepulchre Adored by Saints and Angels*). Still more divergent from Andrea's style was that of the Buglionis, to whom should be ascribed the *Christ Crucified* in the museum of the sanctuary, the work of Benedetto Buglioni, and the *Deposition*, modeled no later than 1532 by Santi Buglioni for the Chapel of Conte Francesco di Montedoglio, at the beginning of the corridor that leads to the Chapel of the Stigmata.

Andrea della Robbia's intervention on La Verna commenced with the *Annunciation* (ca. 1475) and the *Adoration* (1479) on the altars of the two chapels in the form of *aediculae* in the upper church. These were the contributions of the Florentine family of Niccolini and that of the Brizis of Pieve Santo Stefano to the fittings of the Sacro Monte. It continued in the Chapel of the Stig-mata with the *Crucifixion*, commissioned from the sculptor by the Alessandri family in circa 1480, and in the church of Santa Maria degli Angeli with the *Madonna della Cintola*, ordered around 1486 by the Bartoli and Rucellai families. It was brought to a conclusion with the *Ascension* in the Ridolfi Chapel of the upper church, along with the *Saint Francis* and *Saint Anthony Abbot*.

The important role played by the artist in the ornamentation of the monastery, which had undergone extensive reconstruction after the fire that occurred sometime around 1468 (an undertaking sponsored by the Wool Guild of Florence), and a sort of coincidence between the chronological sequence of the altarpieces and a logical iconographic succession — in which episodes from the life of Christ are interwoven with Franciscan themes — lead us to believe that patrons and artists were required to follow a precise iconographic program (as was customary in those days). This program was probably drawn up by an influential figure of the Observants who had historical links with the guiding principles of the sanctuary. Such a man as Pier Paolo Ugurgieri, who had already been in contact with the sculptor in Siena and who was twice elected guardian of the monastery in those years (1468, 1472).

In his first important work, the *Niccolini Annunciation*, Andrea della Robbia set out to represent not the central moment of the announcement, but the subsequent one when the angel, kneeling in prayer, awaits with trepidation the response of the Virgin, who bows her head in a gesture of modest reverence, raising her left hand to her breast and holding a prayer book on her knees with the right. The scene, enclosed within a fine, neo-Brunelleschian architectural structure with classical ornaments, includes, set against the vibrant blue of the sky, a vase with handles containing lilies and the Father who, ringed by six cherubim, sends the mystic Dove toward the Virgin.

The typology of the Virgin Mary is similar to that of

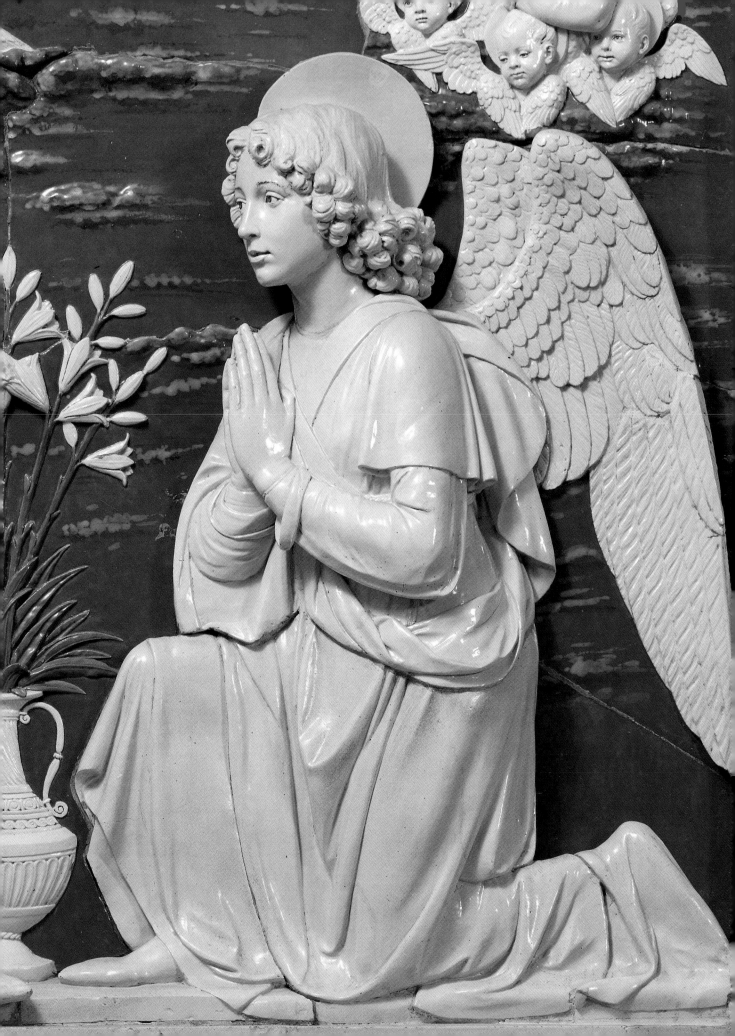

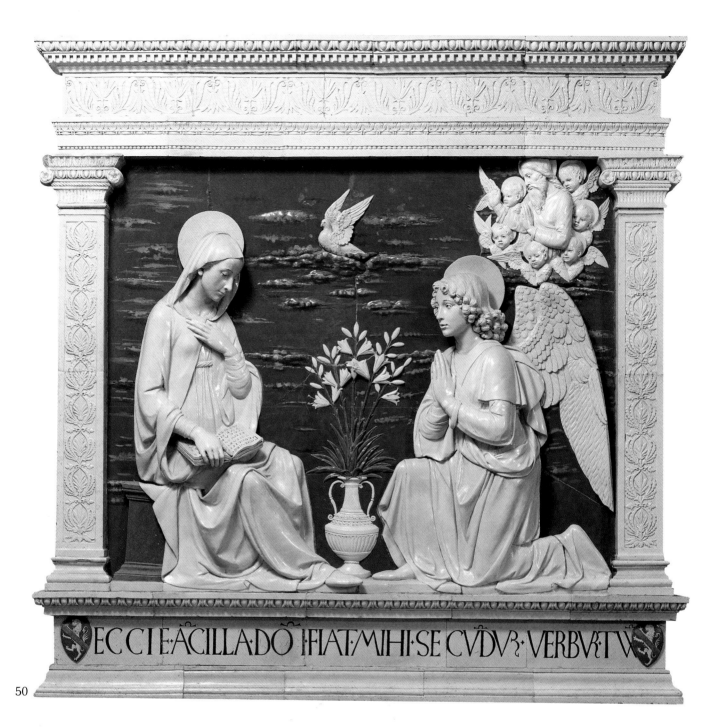

ECCI EACILLADO IFIAT MIHI SE CVDVR VERBVRTV

50

the *Madonna of the Architects* or the *Madonna del Cuscino* (*Madonna of the Cushion*) in the Bargello, modeled by Andrea around 1475. The treatment of the figure also reveals Neo-Gothic inflections in the manner of Andrea Pisano and the influence of Fra Angelico, as is suggested by the slender structure of the body that can be glimpsed beneath the clinging drapery and the particular rendering of the face, where the graphic delicacy of Fra Angelico seems to temper the more obtrusive plasticity of Pisano. If we examine the angel carefully we find, apart from the inevitable reference to contemporary works by the sculptor, such as the *Archangel Michael* in the Metropolitan Museum in New York, a close resemblance to some of Verrocchio's figures, for instance to the *David* in the Bargello (prior to 1476). Look, in particular, at the clear and sharp profiles of

the two figures and the plastic representation of the two curly heads of hair. However what is missing from Andrea's angel is the fleeting and enigmatic smile on the face of the bronze *David*, an element that was later to be taken up by Leonardo.

In the *Brizi Adoration* in the companion chapel to the Niccolini one, on the right-hand side of the transept of the upper church, the artist gives rein to a more exuberant narrative vein: here the scene of the Adoration is combined with the glory of the angels, the despatch of the Dove, and the astonished admiration of the Father, who is portrayed wearing a crown and surrounded by a cloud of six winged cherubim. Note too the greater tendency toward verticality in the altarpiece, a forerunner of the tall altarpieces of later years. It also represents the first use of winged cherubs as an ornament to the

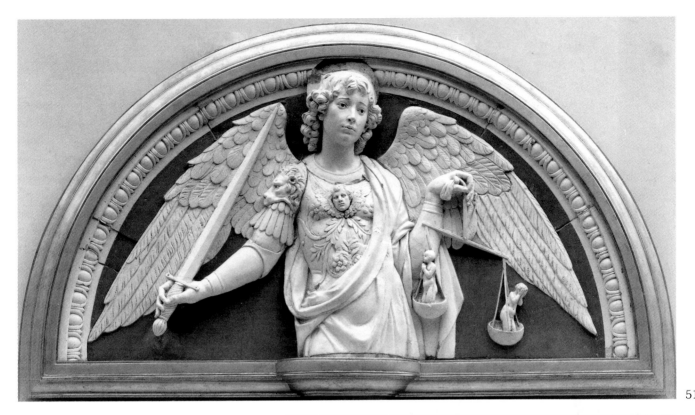

51

49, 50. Andrea della Robbia
Annunciation
210x210 cm
La Verna (Arezzo), Upper Church

51. Andrea della Robbia
Archangel Michael
New York, Metropolitan Museum of Art

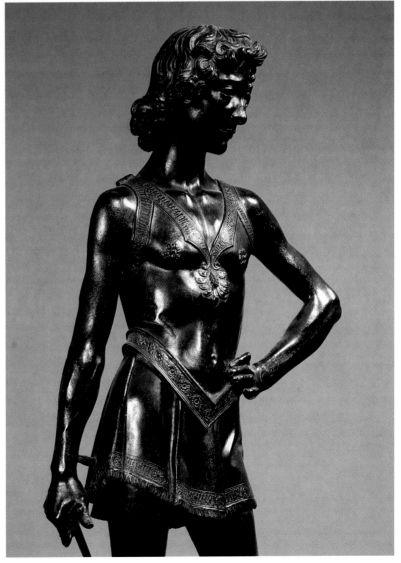

52. Andrea Verrocchio
David
Florence, Museo Nazionale del Bargello

52

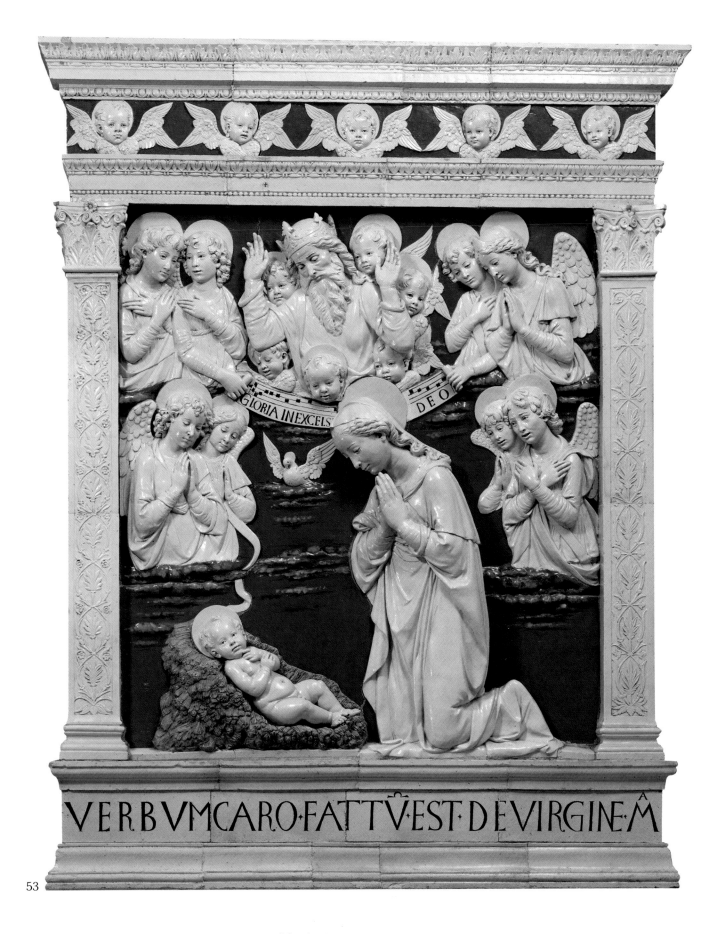

GLORIA INEXCELS DE O

VERBVMCARO·FATTVEST·DE·VIRGINE·M

53

53. *Andrea della Robbia*
Nativity
240x180 cm
La Verna (Arezzo), Upper Church

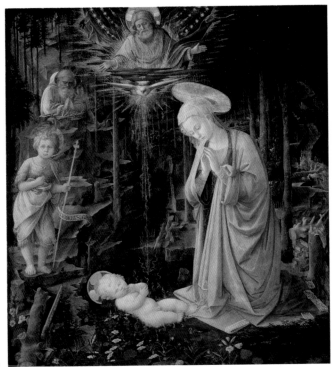

54

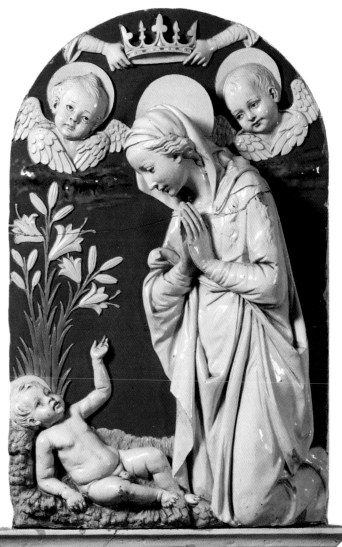

54. Filippo Lippi
Adoration in the Wood
Berlin-Dahlem, Gemäldegalerie

55. Andrea della Robbia
Adoration of the Child
Florence, Museo Nazionale del Bargello

architrave, a formula that would be frequently adopted for the friezes of della Robbia altars from that time on. For the iconography of the Adoration the sculptor must have drawn not only on the vast della Robbia repertory but also on the models offered by painters, especially Lippi and his circle, as is suggested by the close resemblance of the glazed altarpiece to the *Adoration in the Wood* painted by the Carmelite monk around 1460 for the Palazzo Medici on via Larga (Berlin-Dahlem, Gemäldegalerie).

In the *Madonna della Cintola*, realized around 1485 for the main altar of Santa Maria degli Angeli, Andrea della Robbia continues to use the structure of the altarpieces of the seventies, but in the *Alessandri Crucifixion* the artist introduces a new typology, one that was unprecedented in painting in those years: the unitary altarpiece consisting of a single scene. It is used again in the *Ascension*. The work, which takes up the entire rear wall of the Chapel of the Stigmata, replaced fourteenth-century frescoes by Taddeo Gaddi and Jacopo del Casentino. The sacred representation is enclosed by a double frieze with winged heads of cherubim and symmetrical bunches of leaves and fruit. To illustrate the dramatic event Andrea della Robbia makes use of all the iconographic elements associated with it: the pelican feeding its young with the blood from its own breast, the skull of Adam, and the grieving Sun and Moon. The latter are splendid masks, especially the Sun whose golden rays recall the symbol of St Bernardine, but which also draws on the Humanistic repertory, figuratively evoking the mythological Medusa's head. The work, executed in 1480-1481 and a reference point for the later *Trinity* in the Arezzo Cathedral (1484-1485), maintains the equilibrium of the earlier altarpieces even though the folds of the angels' clothing are made to look thicker against the atmospheric blue of the background.

The "Peruginesque" *Mond Crucifixion* that Raphael painted in 1503 for the church of San Domenico in Città di Castello displays considerable similarities to the La Verna altarpiece, especially in the overall scheme of composition, leading us to reflect further on the influence that Andrea della Robbia's works may have exercised over the formative period of the painter from Urbino.

The last important work to have been executed by Andrea della Robbia himself for the La Verna monastery

49

was the *Ascension*, realized around 1490 for the main altar of the upper church and then moved, in 1601, to the Ridolfi Chapel, the first on the left toward the presbytery. In all probability it was the Medici family and not the Ridolfis who ordered the work from the sculptor. In fact the *Ascension* was intended for the chapel built in 1457 by Pierfrancesco dei Medici, who was not the only member of the family to have been involved in the history of the celebrated monastery. Others included Lorenzo il Magnifico, Lucrezia Tornabuoni, Cosimo I, Eleonora of Toledo, and Clement VII. The absence of the coat of arms of Andrea's patrons, as in the preceding altars, actually strengthens our proposal, for it would not have seemed indispensable for the decoration of the main chapel, which had always belonged to the Medici. A document from 1532 refers to the need to replace the sacred paraments of the choir, which had been donated by Lucrezia Tornabuoni. Clement VII, formerly Cardinal Giulio dei Medici, was to undertake the task. Consequently it is impossible to believe that the Medici family would not have wanted a suitable decoration for their altar or that, as many have supposed, they handed the chapel over to the Ridolfi family around 1490, in view of the fact that its fittings were still in their possession in 1532.

Apart from the indisputable quality of the work, one notes a certain discontinuity of style, for instance in the precise modeling of the heads of the Apostles and the Virgin and the sparer and more monotonous handling of the drapery. It is likely therefore that Andrea, busy on other commissions in those years, left the task of finishing the altarpiece to one of his collaborators. But we do not know who it was that assisted Andrea in the execution of the *Ascension*. Given the scale and continuity of the work done by Andrea, it is certain that he relied on the help of a number of collaborators, some of whom were capable of introducing new elements to the artist's customary language. The marked naturalism and the richer coloring of the *Nativity* and *Christ in Sepulchre* in Santa Maria degli Angeli, which can be dated to about 1493, hint at the involvement of a new artistic personality. I have put forward the name of Francesco della Robbia, the future Fra Ambrogio, who from 1636 onwards is cited in the historiography of La Verna as the author of the monastery's altarpieces. The highly devotional character of the two works is also in accord with the ardent religious zeal of Andrea's son who, only a few years later, was to receive the Dominican habit from the hands of Savonarola.

Thus the della Robbia *corpus* of La Verna remains

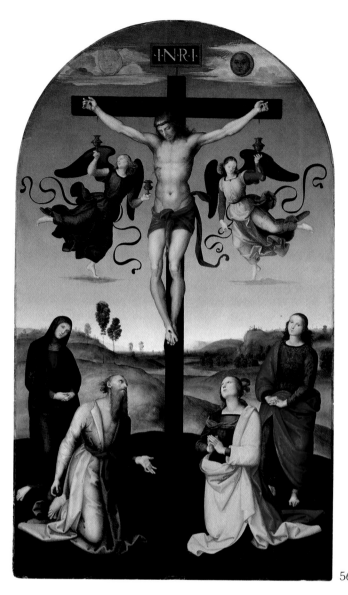

56

56. Raphael
Mond Crucifixion
London, National Gallery

57. Andrea della Robbia
Alessandri Crucifixion
600x420 cm
La Verna (Arezzo), Chapel of the Stigmata

one of the highest testimonies to the work of a team, in which the head of the studio was assisted in his labors by a variety of collaborators and in some cases even substituted by one of them.

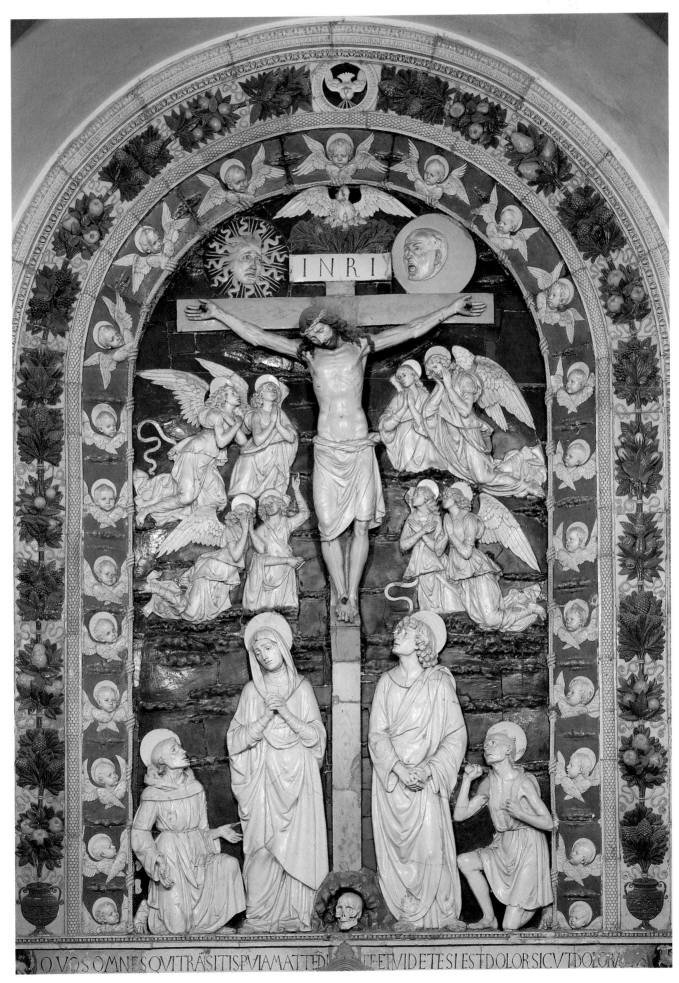

O VOS OMNES QVI TRÃSITIS PVIAM ATTED... ET VIDETE SI EST DOLOR SICVT DOLOV

58. Andrea della Robbia
"Madonna della Cintola"
388x236 cm
La Verna
(Arezzo), Church
of Santa Maria
degli Angeli

59. Andrea della
Robbia
Ascension
457x308 cm
La Verna
(Arezzo), Upper
Church

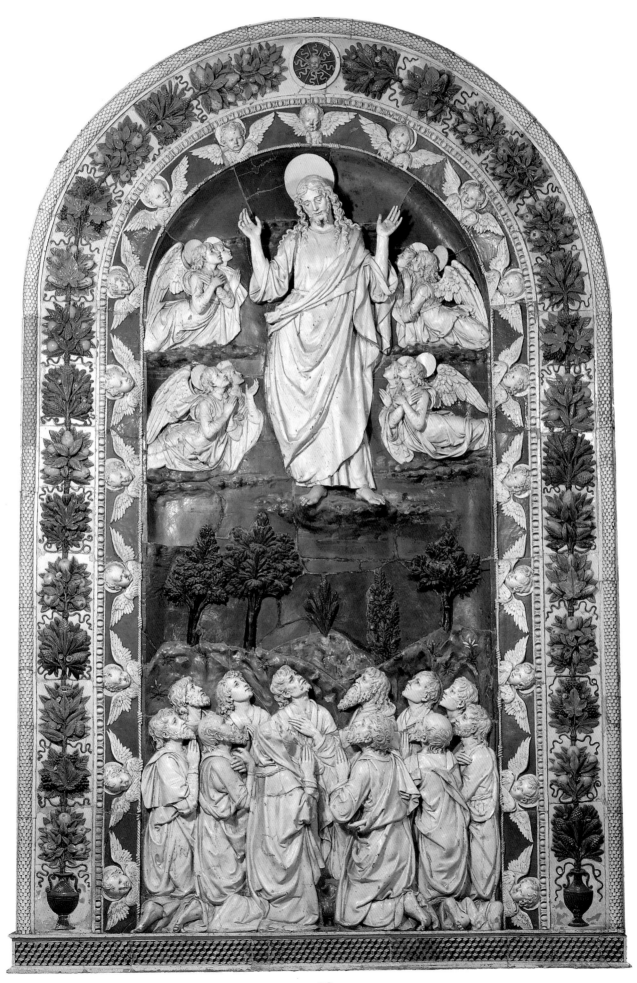

59

Andrea della Robbia: the later production

The last decade of the Quattrocento found the sculptor overloaded with commissions for the decoration of "reformed" churches and monasteries, as well as with orders from the cultivated Florentine bourgeoisie, who had previously given their custom to Luca.

His intervention in the church of Santa Maria delle Carceri in Prato during the last decade of the century, as a complement to the work of the architect Giuliano da Sangallo, shows that Andrea had now become the decorator of preference for architects belonging to the Medicean circle, such as Giuliano da Maiano and Sangallo. At the close of the fifteenth century — particularly delicate and difficult years for Florence, following the death of Lorenzo il Magnifico in 1492 and culminating in the burning of Savonarola at the stake (1498) — Andrea's art assumed a greater liveliness of form that had not been seen in his earlier work.

In the *Annunciation* in the cloister of the Spedale degli Innocenti or Foundlings Hospital, executed around 1493 to a commission from Francesco del Pugliese, the two figures, and the angel in particular, display a more impassioned style in the tangled and tortuous representation of the drapery. The opulence and intricacy of the clothing can be explained by the influence on the artist of the studies of drapery carried out in Verrocchio's studio and by his interest in the bronze group of the *Doubting of Saint Thomas* in Orsanmichele.

Andrea della Robbia's contribution to the decoration of the famous Florentine hospital also extended to the tondi with swathed putti in white glazed terracotta on a blue ground in the roundels of the external portico, which were set in place in 1487. Luca della Robbia, a friend and collaborator of Brunelleschi, must have been involved in the original design.

Making use of a richer and more varied range of colors, typical of some of the work produced by Andrea and the studio at the end of the century, the artist set about the decoration of Michelozzo's loggia of the hospital of San Paolo dei Convalescenti (ca. 1493-1495) with tondi depicting figures of *Saints* and *The Seven Acts of Mercy* and with two half medallions bearing the portrait of the hospital director, *Benino Benini*. The masterpiece and focal point of the work done by the sculptor for San Paolo is the *Embrace between Saint Francis and Saint Dominic*, symbolizing the union of Franciscans and Dominicans. This was a particularly favored theme in religious circles at the end of the century, alluding to the reconciliation that had taken place between the Franciscan Pinzocheri family, owners of the hospital, and Antonino Pierozzi, the Dominican archbishop of Florence who was later canonized as St. Antonino, following a number of disputes that had arisen over the construction of the monument.

The emotional and sentimental intensity of the lunette echoes the feelings expressed by Luca in the *Visitation* (ca. 1455) in San Giovanni Fuorcivitas in Pistoia — where the accentuated realism of St. Elizabeth's wrinkled face and her desperate gesture of entreaty suggest to me the intervention of Andrea under the influence of Verrocchio. But the monumental stature of the two holy founders, whose elongated bodies wrapped in their respective habits (brown frock with hood for Francis, white frock with knotted cord round the waist for Dominic) jut out strongly from the atmospheric background, projecting beyond the semicircle of the lunette, is indicative of the shift, in Andrea's art, toward fuller and more dramatic forms. This was in line with the general tendency in Florentine art toward the end of the century to prefer monumental and imposing compositions. In the hollow cheeks and penetrating gaze of Francis and Dominic, and in the representation of their nervous hands, in which one can even see the quiver provoked by the warmth of that embrace, there is a more realistic and dramatic sentiment, achieved in part through the substitution, for the flesh tones, of a light natural coloring instead of glazing, producing a greater effect of naturalism.

So a dramatic realism of Savonarolian stamp and a grandeur of composition that offers a foretaste of sixteenth-century monumentalism are the distinctive features of the lunette in the hospital of San Paolo. It was the last documented important work by Andrea della Robbia in Florence to have survived, given that no trace is left of the *Resurrection* and the frieze with cherubim and seraphim in the church of San Frediano that he started to work on for the Company of San Frediano in 1494 and returned to in 1517-1518.

In Santa Maria delle Grazie outside Arezzo, center for the propagation of St. Bernardine's reforms, Andrea della Robbia carved a marble altar toward the end of the fifteenth century as an ornament to the *Madonna della Misericordia* (*Madonna of Mercy*), painted by Parri Spinello. The high quality of the work, the only one of Andrea's in marble that we know of, and the fine design of the ornamental motifs lead us to suppose that he actually made greater use of this medium, an idea that is reinforced by Vasari's comment that "he worked very well in marble."

The *Pietà* below the altar is comparable to similar compositions by Andrea, such as the *Pietà* in the

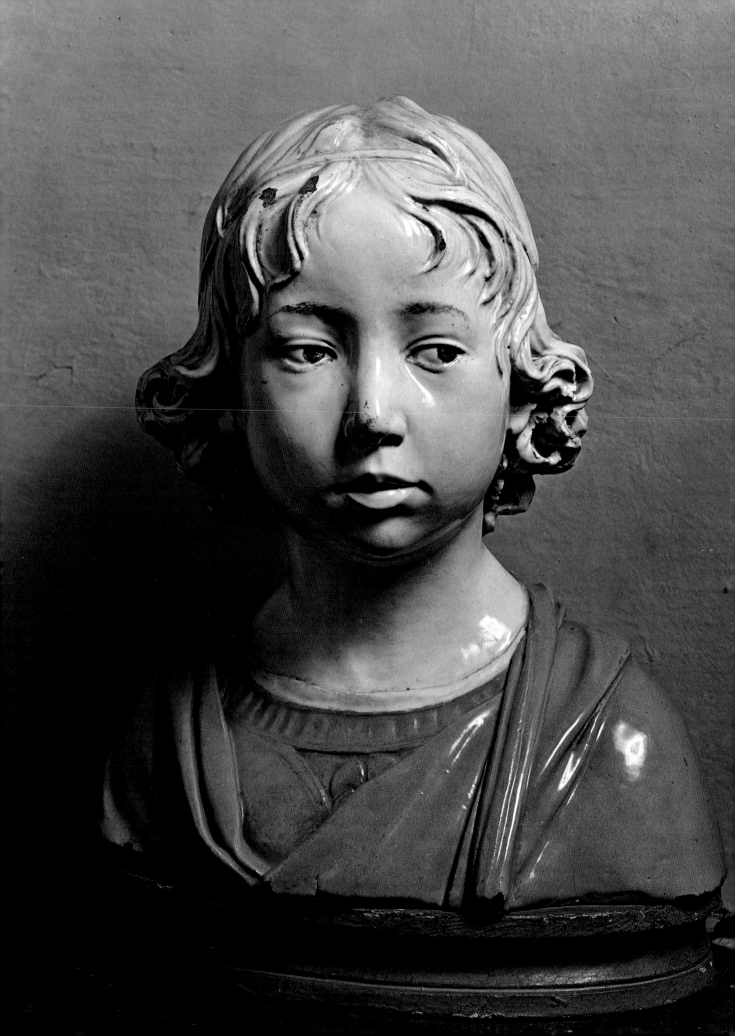

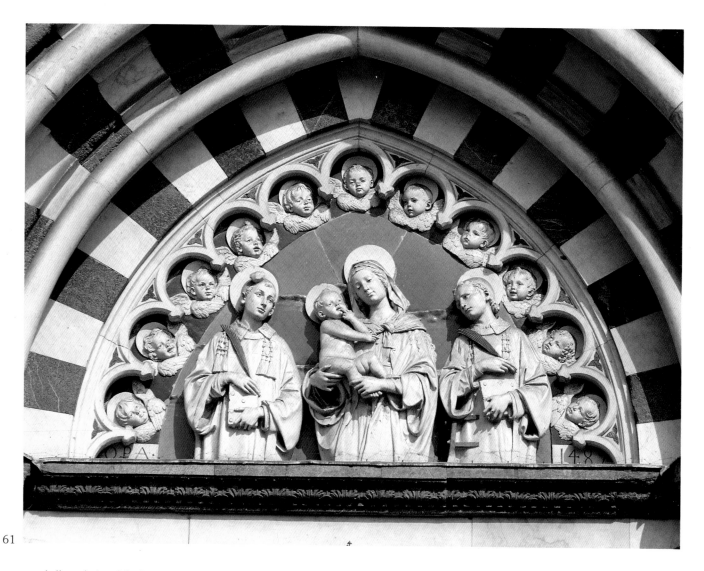

61

predella of the *Madonna della Misericordia* in Santa Maria a Gradi in Arezzo and his version of the same theme on the base of the *Nativity* in the lower church on La Verna. The elegant architectural structure of the altar was to influence Giovanni della Robbia at the time of his execution of the *Lavabo* in Santa Maria Novella, to whose design Andrea himself must have contributed.

Just as had happened during the juvenile phase of Andrea's career, with Giovanni's early works it is hard to tell to just what extent they were the spontaneous fruit of the young sculptor's own intellectual capabilities or on the other hand a reflection of the talent of the older artist.

Andrea della Robbia's last important works date from the first decade of the Cinquecento and were produced for the Pistoia Cathedral and for the church of Santa Maria della Quercia in Viterbo.

In Pistoia Cathedral, garlands of plants and a dense, ornamental pattern of yellow rosettes on a blue ground alternating with blue panels bearing white plant motifs and other ornaments were applied to the archivolt and to the vault of the portico respectively. In the middle of the lunette the sculptor modeled the *Madonna and Child* crowned by two angels in flight. The asymmetry of the composition, with the Madonna not on the center line but displaced slightly to the left, is surprising, especially in view of the fact that Andrea personally supervised the installation of the bas-relief in the lunette along with "one of his sons and an apprentice" called Michele, spending about a month in the city during the summer of 1505.

The figures are distinguished by a new sturdiness and strength of the limbs and a greater fullness of drapery. Let us stop for a moment to look at the cloak of the Virgin, at the long folds of the armhole that hang down on the left, something unheard-of in the Marian compositions of previous years. In short, one can see in Andrea's production during the first decade of the sixteenth century an echo of that breadth and scale of form, of that monumental character and sometimes heroic emphasis that are common to all the classics of the Cinquecento. However it was only a superficial reference, which did not have the force to break down the static quality and archaic stillness of Andrea's art, only distantly affected by the impassioned approach to composition and dramatic sense of movement that were then creeping into the works of Fra Bartolomeo, Andrea del Sarto, and even Sansovino, who is known to have been a client of the workshop on via Guelfa.

Making use of broad rhythms on a grand scale, set

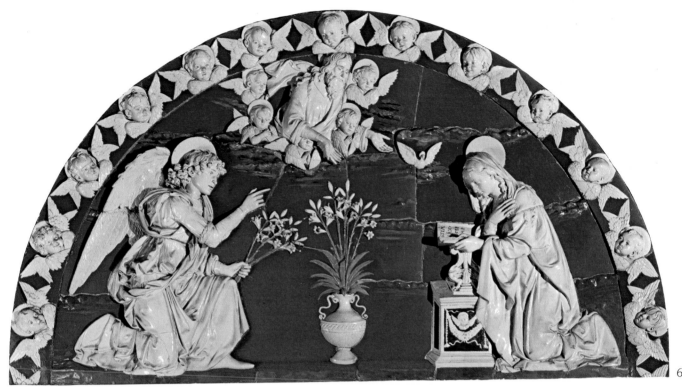

62

60. *Andrea della Robbia*
Bust of a Boy
h. 33 cm
Florence, Museo Nazionale del Bargello

61. *Andrea della Robbia*
Madonna and Child between Saints Stephen and
Lawrence
163x263 cm
Prato, Cathedral

62. *Andrea della Robbia*
Annunciation
154x285 cm
Florence, Spedale degli Innocenti, Cloister

63. *Andrea Verrocchio*
The Doubting of Saint Thomas
Florence, Church of Orsanmichele

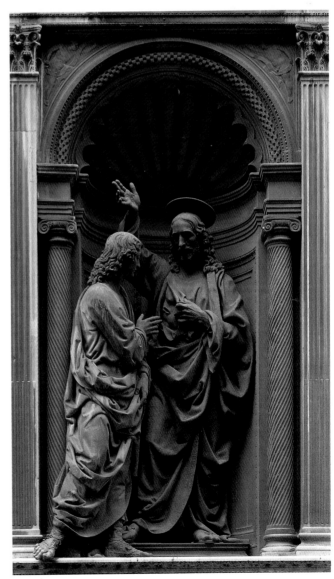

63

within a rigidly frontal compositional structure in the
fifteenth-century style, Andrea della Robbia executed
in the years 1507-1508 three lunettes for the facade
of Santa Maria della Quercia in Viterbo. In the lunette
of the main portal he depicted the *Madonna and Child*
between Saints Dominic and Lawrence, patron of the
city, and in the lateral ones *Saint Peter Martyr* and *Saint*
Thomas Aquinas, both portrayed between two angels.
The preference accorded to Andrea's terracottas for the
decoration of the facade of the Dominican church, sub-
ordinate to the Congregation of St. Mark and in those
years under the priorship of the Florentine Fra Filippo
Strozzi, is a testimony to the still high esteem in which

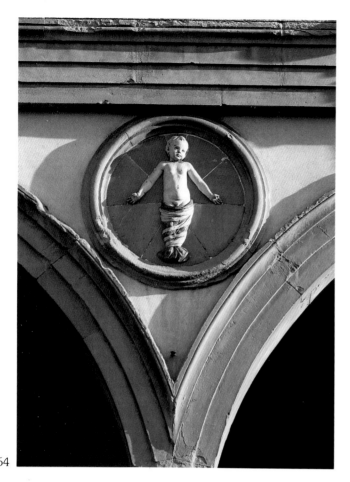

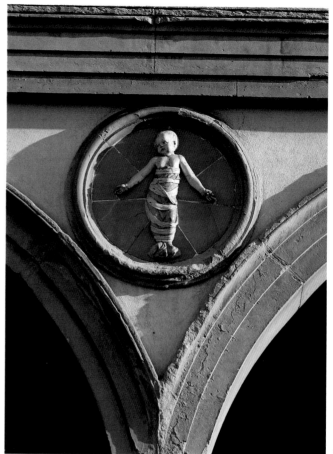

64. *Andrea della Robbia*
Putto in Swaddling-Clothes
Florence, Spedale degli Innocenti, Portico

65. *Andrea della Robbia*
Putto in Swaddling-Clothes
Florence, Spedale degli Innocenti, Portico

66. *Andrea della Robbia*
Embrace between Saint Francis and Saint Dominic
140x270 cm
Florence, Spedale di San Paolo, Loggia

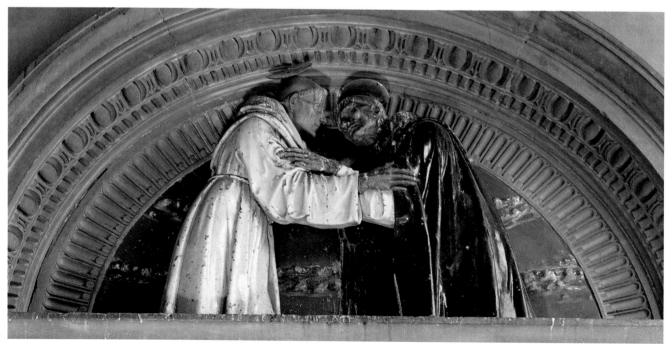

58

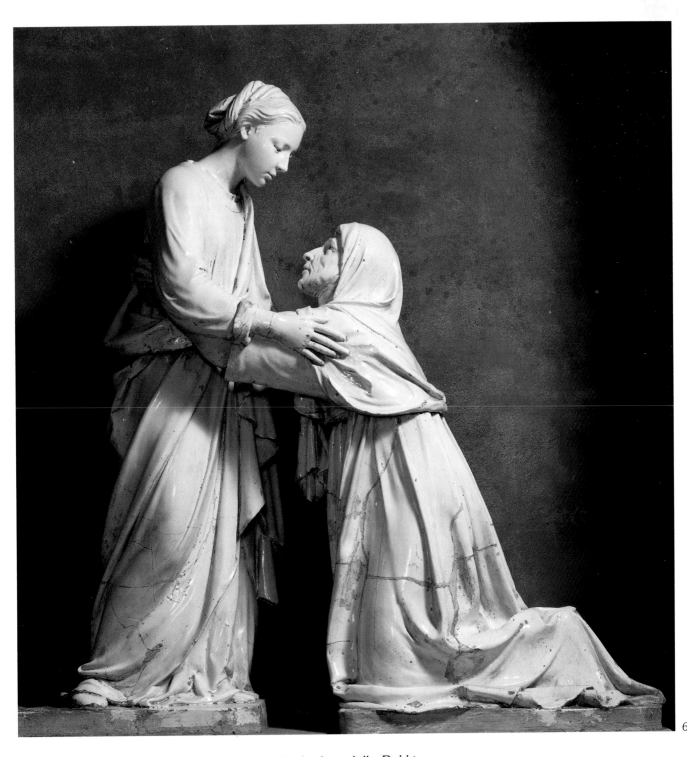

67

67. Andrea della Robbia
Visitation
184x153 cm
Pistoia, Church of San Giovanni Fuorcivitas

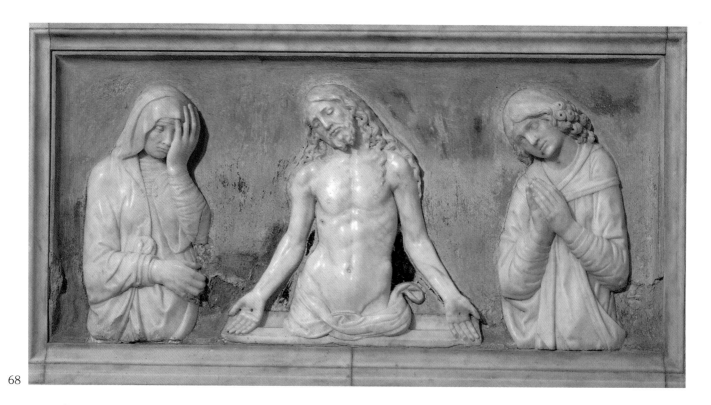

68

Andrea's art was held in those centers, like Viterbo, where the prestige of the monastic communities had encouraged the introduction of the Florentine figurative culture of the early Cinquecento.

The three lunettes, for which the sculptor received a payment of forty ducats, were transported to Viterbo by the carter Domenico da Ricorboli and preceded the work that Andrea carried out for San Giovanni Battista. The iconography of the central group of the lunette on the main portal, representing the Madonna and the Child raising His hand in blessing along with two soaring angels holding a crown, with branches of oak leaves in the background as an allusion to the historical foundation of the church, is drawn from Andrea's extensive repertory at the end of the century. In the new century Andrea della Robbia received other commissions after

the ones for Viterbo, remaining essentially loyal to *fin de siècle* figurative esthetics.

In the meantime broader horizons and frontiers were opening up with Leonardo, Michelangelo, and Raphael. A new dynamic and organic perspective was breaking down the static and geometric vision of the preceding century; a new atmospheric, mellow, and shaded style was coming into vogue and the forms acquired a heroic plasticity that was unknown to fifteenth-century artists. The Florentines were enraptured by the cartoon of St. Anne that Leonardo had produced in 1501 for the Servites of the church of Santissima Annunziata; when displayed to the public, it met with such success that "[...] for two days it attracted to the room where it was exhibited a crowd of men and women, young and old, who flocked there, as if they were attending a great fes-

69

68. Andrea della Robbia
Pietà
Arezzo, Church of Santa
Maria delle Grazie

69, 70. Andrea della
Robbia
The Trinity Altarpiece
and detail of the
predella
370x260 cm
Arezzo, Cathedral

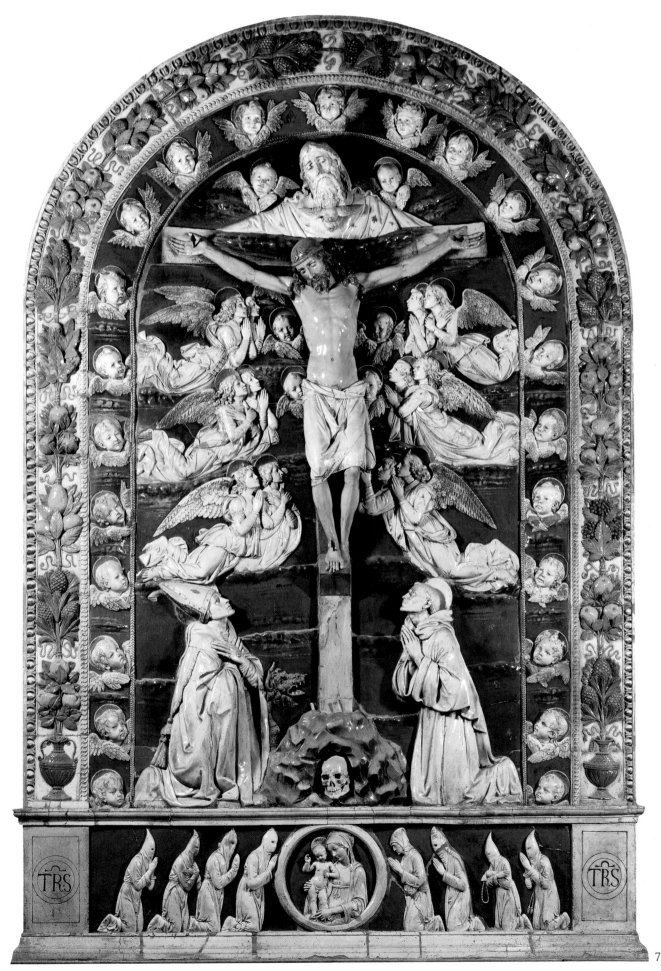

61

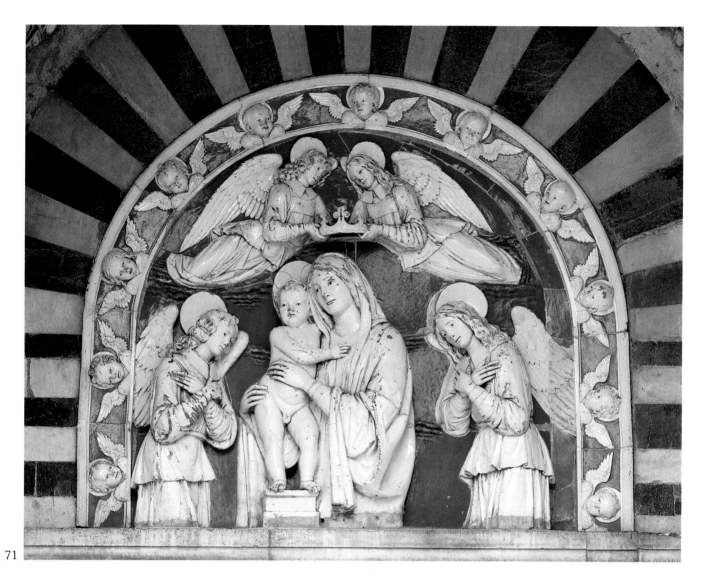

71

71. Andrea della Robbia

71. Andrea della Robbia
Madonna and Child between Angels
160x220 cm
Pistoia, Cathedral

tival." What more could the last survivor of the Florentine sculptors of the Quattrocento have to say to them? How could the fragile terracottas of Andrea bear comparison with the marble colossi that were being carved by Michelangelo? How could his delicate forms stand up to the athletic force of Michelangelo's?

The aging sculptor, whom Andrea del Sarto portrayed "in an old red garment, stooping with a stick in his hand" in the scene representing the *Investiture of Saint Philip Benizi* on the walls of the little cloister of Santissima Annunziata around 1510, died in 1525 at the age of ninety.

By that date Luca the "Younger" had already joined his brother Gerolamo at the court of Francis I in Paris, while Giovanni kept the studio going in Florence. It re-

mained active until his death, in 1529. Thus Florence, which had seen the rapid ascent of the art of the della Robbias, now watched, almost with indifference, its equally rapid decline. "For Florence," Vasari would explain, "does with its artists what time does with its own things, and having made them unmakes them and consumes them little by little."

Expansion and development of the workshop

The greatest stumbling-block encountered by anyone who makes the attempt to rescue a fair proportion of the glazed terracottas of the late Quattrocento and early Cinquecento from the generic classification of "della Robbias" or from their attribution, equally generic, to the "studio," consists in the scarcity of documents relating to the organizational structure of the workshop on via Guelfa and to the identity of assistants and collaborators.

During a period like the one at the turn of the century, in which a sort of intellectual emancipation of the figure of the artist was taking place, so that he was no longer a mere craftsman but an intellectual, as is testified by the large collection of books in the possession of Benedetto da Maiano, and in which the workshops were turning into authentic academies in miniature where, as Vasari records, "very fine discourses and important debates" took place in the evenings, the studio on via Guelfa was also expanding and growing more professional. The credit for this is due largely to Andrea and his sons, but artists like Benedetto da Maiano, Giovan Francesco Rustici, the Master of the Young Saint John, and the two Sansovinos also played their part by entrusting the workshop with the glazing of their products, thereby guaranteeing their quality and also encouraging the assimilation of stylistic elements from outside the Della Robbia circle. This is the reason for the difficulties encountered in attribution and for the importance of a carefully considered and prudent approach to criticism that can lead, wherever possible, to a more appropriate authorship for the works.

In the vast production of terracottas under Andrea, we can make a primary distinction among the works done by the sculptor himself with the secondary intervention of assistants, the ones that can be attributed to other artists active in the via Guelfa studio, and finally the ones produced by assistants who limited themselves to reproducing, by means of molds and casts that frequently deteriorated with use, the models of the master, giving rise to a standardized production of mediocre quality. Let us go back for a moment to La Verna: here there are works, like the *Ascension*, where the involvement of assistants is limited; others, like the two side altarpieces in the lower church, representing the *Deposition* and the *Crucifixion* in the Montedoglio Chapel and the museum respectively, that suggest the intervention of new artists; and still others, like the *Madonna del Rifugio* (*Madonna of Refuge*) on the first altar on the right in the upper church, that are feeble reinterpretations of well-known della Robbia *Sacre Conversazioni*.

As for the prices charged, it was the practice among painters at that time to ascribe a much higher value to the work of the master than to that of his collaborators. In 1477, for instance, Pope Nicholas V paid Fra Angelico a fee that was over twice the amount received by Gozzoli and his other assistants. If this held true for the della Robbia terracottas as well, then Andrea's works were charged at a higher rate than the ones entrusted to his collaborators, even when of equal quality.

The *Nativity* and *Christ in Sepulchre* on the side altars of the lower church on La Verna, documented in 1493, are worthy of separate treatment, since they represent one of the first examples of polychrome glazed altarpieces to have been produced by Andrea's circle and therefore constitute a fundamental point of reference for the decoration of churches belonging to the Minorite Observants.

In the *Nativity*, the central group of the Madonna with the Child and St. Joseph is flanked by the elongated figures of St. Anthony and St. Francis; the narration is enriched by the addition of the Dove despatched by the Father, who is portrayed in a cloud of cherubim, and of the glory and adoration of pairs of angels. Color is used for the flesh tones, with a naturalistic effect, and for the hair, wings, and clothing, making it possible to draw a close comparison between the altarpiece in relief and painted panels. The typology of the figures, the original ornamentation of the architectural structure, and the detail of the Virgin's hair, loose and not gathered under a veil as Andrea used to represent it in those years, all tend to suggest the involvement of a new artistic personality. Working in the studio and yet with his own freedom of expression, he may have been one of the sculptor's sons still under the influence of the paternal entourage.

The *Christ in Sepulchre* on the companion altar of Santa Maria degli Angeli should be ascribed to the same hand. It represents Christ supported and mourned by the Virgin and St. John, while further back two angels hold Him up by the arms. The insistence on the instruments of the Passion (the crown of thorns and the lashes hanging from the cross, the spear and the sponge out-

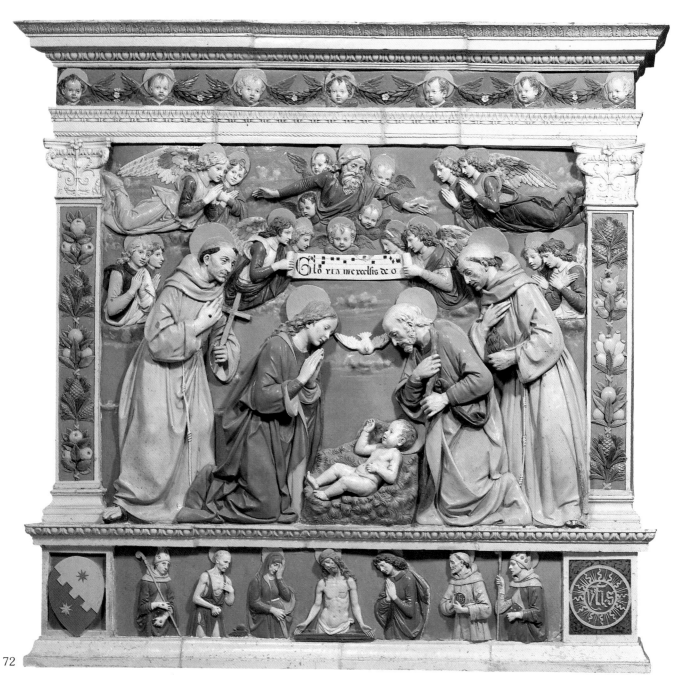

72

lined against the blue of the panel) and the motif, enormously popular and moving, of the *vir dolorum* as an object of meditation for the devotee, which was dear to monastic art and well-known in Florence, largely through the work of Lorenzo Monaco (cf. *The Man of Sorrow*, Accademia, Florence), hint at a connection with the Savonarolian piety of Andrea's sons. One of them, Francesco della Robbia, is cited by historians of La Verna from the seventeenth century onward as the author of the altarpieces in the monastery. The markedly devotional character of the two altars is compatible with the ardent religious zeal of Francesco, who entered the monastery of San Marco at the age of eighteen under the name of Fra Ambrogio. The lack of documented contemporary works by the artist places limits on the credibility of this proposal of ours, but it is intended merely as one possibility in the still open question of

the part played by Andrea's sons in della Robbian production at the end of the century.

Further examples of the activity of the studio during this period are the *Adoration of the Shepherds* in Città di Castello (Pinacoteca) and the one in the church of Santa Chiara in Monte San Savino, in partially glazed and polychrome terracotta. The elaboration and maturation of this theme was to lead to the marvelous *Adoration of the Shepherds* in San Lorenzo in Bibbiena. Here the prestige of the commission, made at the behest of Leo X and Cardinal Bibbiena, would have required the intervention of an outstanding artist, known to and esteemed by pontifical circles. This may have been Luca the "Younger," Andrea's son and — as we shall see shortly — Raphael's collaborator in the Vatican.

The *Intercession of Christ and Saints* in San Francesco in Foiano and the *Pentecost* in San Matteo in

64

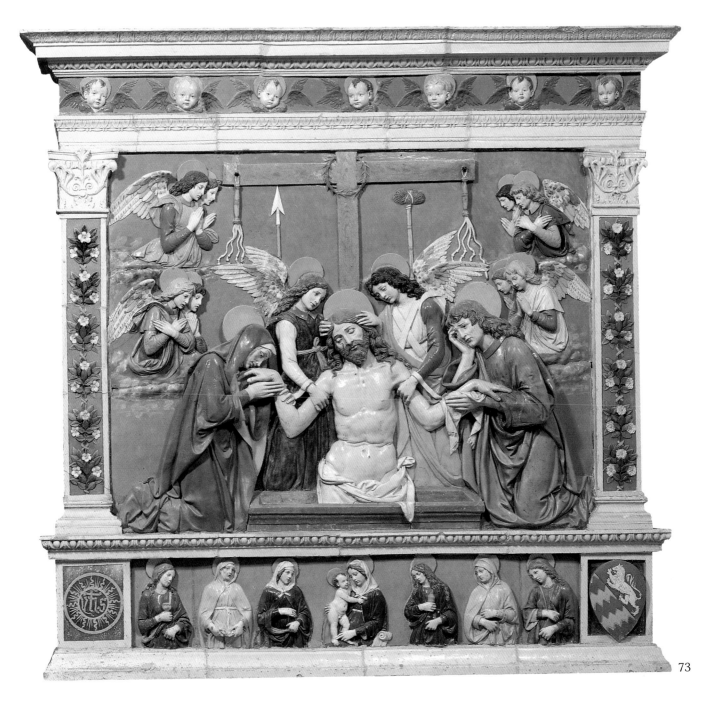

73

72. *Francesco della Robbia (attr.)*
Nativity
185x185 cm
La Verna (Arezzo), Church of Santa Maria degli Angeli

73. *Francesco della Robbia (attr.)*
Christ in Sepulchre
La Verna (Arezzo), Church of Santa Maria degli Angeli

Memmenano both use the typology of the Eternal Father inside concentric bands with cherubim, drawn from the repertory of Andrea in the eighties, and share the motif of adoring angels in flight, but there is an essentially new aspect to them as well. A stylistic examination of the *Pentecost* in particular suggests the work of an artist who is less bound by the prototypes of the studio and more open to the new trends of the early Cinquecento. In the new century, in fact, it would be the youngest sculptors active in the workshop on via Guelfa who would come up with new solutions as an alternative to those of the aging master, works that were more strongly influenced by modern painting and sculpture and that broke away from the mediocrity of invention and style that prevailed in the later output of Andrea della Robbia's studio.

Giovanni della Robbia

By 1525, the year of Andrea della Robbia's death, the game was over: having been in the forefront of the renewal of the arts in the previous century, the art of the della Robbias was now on the wane, finding it impossible to coexist with the new themes tackled by Florentine artistic culture in the early sixteenth century. The taking over of the studio by Andrea's third-born son, Giovanni della Robbia (Florence, 1469-1529), did not serve to improve matters and to check the decline of via Guelfa. A decisive role in this decline was played by the various destinies of Giovanni's four brothers — Francesco, Gerolamo, Luca, and Marco — who at different times and in different ways moved away from the studio, depriving it of their creative talents and of a fertile input of ideas and original works. The space that Vasari gives to Giovanni della Robbia in his *Lives* is minimal with respect to that accorded to Andrea's other sons: "[…] Giovanni," he wrote, "devoted himself to art and […] had three sons, Marco, Lucantonio, and Simone, of whom good things were expected, but who all died of plague in the year 1527." While this comment of Vasari's does not do true justice to the artist, it is useful for its reference to the part played in the work of the studio by the sculptor's three sons, promising young men who were snatched away from life and art by the plague that ravaged the city in 1527.

While not disdaining the contribution made by Giovanni to the studio's output, there can be no doubt that the general process of popularization of glazed terracottas entailed a reduction in the quality of many of the works commonly ascribed to the artist and his circle. They were often of a modest and popular tone, devoid of originality and of any, however timid, attempt at renewal along the lines of the monumental sculpture of the sixteenth century.

Giovanni's artistic debut came in 1497, when he produced a work, the *Lavabo* for the Sacristy of Santa Maria Novella in Florence, in which the lessons he had imbibed from Andrea were united with new features, not to be found in his father's production of that time. Right from the start the artist took an exuberant approach to decoration, showing a preference for picturesque effects in his subjects, as is suggested by the delicately shaded landscape from an aerial perspective painted at the back of the niche. Here the relationship with painting is a close one, as can be seen from a comparison with the similar effects pursued years earlier by Perugino in his famous picture of *Apollo and Marsyas* in the Louvre. The painstaking and detailed decoration of the architectural framework, which for the first time in the production of the della Robbias includes the iconographic motifs of the dolphin as an ornament to the capitals and of the pair of vases with handles painted in two-dimensions on the panels at the end of the base, is combined with the rich and succulent garland of plants that frames the semicircle of the lunette and is repeated outside it. The garland is held by two putti in a manner similar to the one carved in marble by Desiderio da Settignano for the *Marsuppini Monument* in Santa Croce (ca. 1453). The adoption of the same solution by Andrea in 1512 for the *Altar of the Sacrament* in the church of Santi Apostoli and the fact that the typology of the *Madonna and Child between Two Adoring Angels* in the lunette is clearly part of the father's repertory demonstrates the closeness of the two artists and even that in some cases Giovanni had something to teach Andrea.

So it appears that the proposal put forward by the sculptor right from his first documented work was a dialectical relationship between plastic and pictorial aspects, with the emphasis on decoration. Not devoid of affectation and technical virtuosity, it was an eclectic style of which Giovanni was to become the main interpreter in the family's production. His undertaking on 26 August 1507 to make 36 wine jars for the Pharmacy of Santa Maria Nuova, at the request of the celebrated hospital director Leonardo Buonafede, is perhaps a confirmation of the flexibility of the artist, sculptor, decorator, and, when necessary, potter as well. Taking commissions from his father's Franciscan patrons, at the beginning of the sixteenth century Giovanni executed for the Observants of San Gerolamo in Volterra the *Last Judgment* and *Saint Francis Delivering the Rule to Saint*

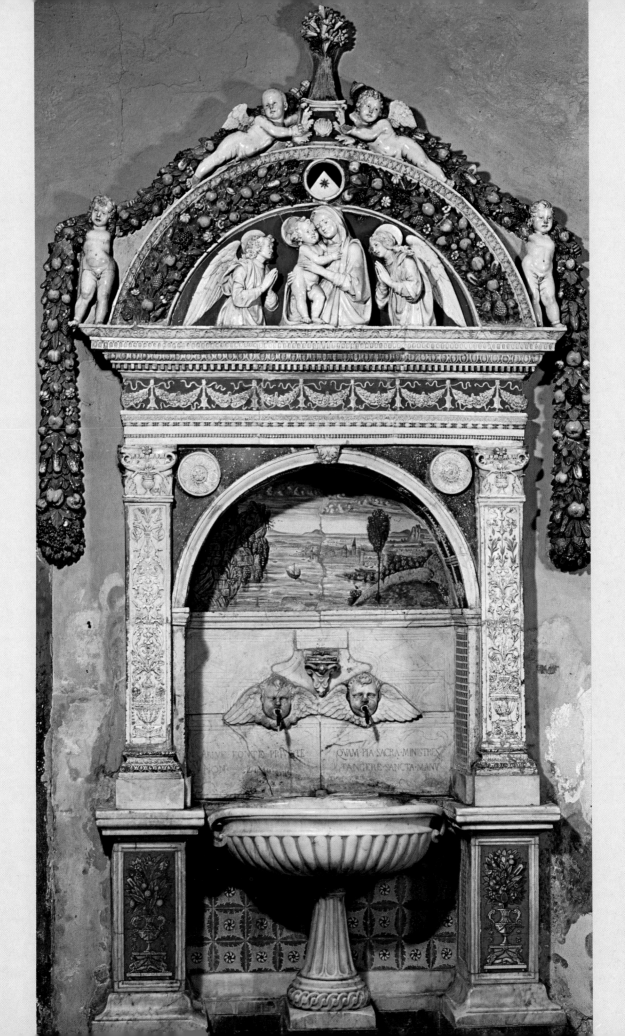

Louis and Saint Elizabeth of Hungary, in whose conception Andrea himself must have played a part. Faced with panels of great size (over two meters in height), the artist exploited all the space available for the unfolding of the narrative, which is clearly derived from works that were well-known in those years. The two predella panels make use of familiar elements of Andrea's typology as well as ornate studio "marks." Thus while the figure of Christ the Judge betrays echoes of Verrocchio, already to be seen in works like *The Doubting of Saint Thomas* (Convent of the Montalve, La Quiete, Florence), and those of the angels are an indisputable reference to Sansovino, the intimate ties with painting maintained by the sculptor are plainly visible in the dancing ring of angels and saints in the background, almost a "quotation" from Fra Angelico, and in the detail of the soul about to be judged by the Archangel Michael. The young man awaiting the verdict, bowing beneath the pressure of the angel's sword poised unsheathed above his head, is strongly reminiscent of the son of the prefect of Antioch, Theophilus, that Filippino Lippi painted in 1480-1481, above the scene of the *Tribute Money*, on the walls of the Brancacci Chapel in Santa Maria del Carmine in Florence. The close link that is established between the two figures by the analogous positions of their slender and trembling bodies and by the similar

treatment of their hands and arms, disposed in a gesture of ready gratitude in Filippino's figure and in one of grieving devotion in Giovanni's, leads one to postulate a deliberate reproduction of Lippi's work on the part of the sculptor. The crowded scene of the *Judgment*, almost an expression of a late-Renaissance *horror vacui*, underscores the deep conflict between naturalism and decoration, between the attempt to be realistic and the desire to be decorative, creating that "poetics of discontent" that was to form the basis of sixteenth-century Mannerism.

The Baptismal Font in the church of San Leonardo in Cerreto Guidi, dated 1511, provides clear proof of the links between Giovanni's production and the models offered him by painting: the six scenes on the sides of the font are highly reminiscent of Ghirlandaio's frescoes in the main chapel of Santa Maria Novella. The *Birth of the Baptist* and the *Naming* can be seen as three-dimensional fragments of Domenico Ghirlandaio's narrative, both in terms of their composition and owing to a similar partiality for precious ornamentation and for representation of the many different aspects of the phenomenal world.

In 1511 Giovanni della Robbia realized an intricate and fussy altar for San Medardo in Arcevia (formerly on the main altar of the hermitage of San Gerolamo

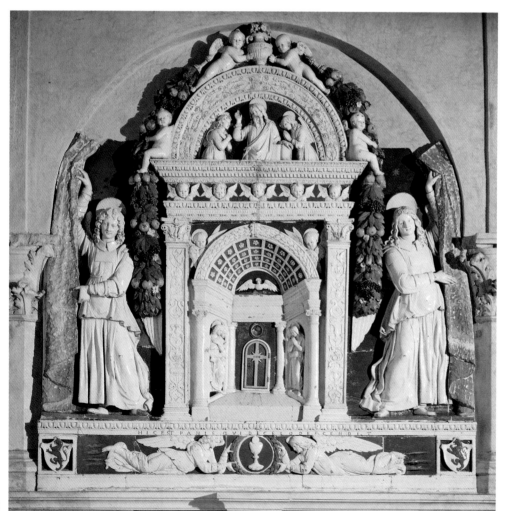

74. *Giovanni della Robbia*
Lavabo
414x234 cm
Florence, Church of Santa Maria Novella

75. *Andrea della Robbia*
Altar of the Sacrament
270x240 cm
Florence, Church of Santi Apostoli

75

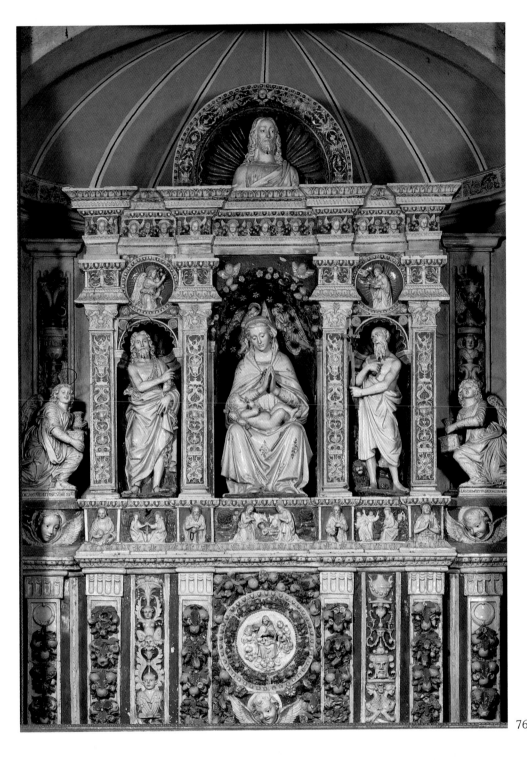

del Sasso Rosso near Arcevia), loading the architectural framework with even more ornamental motifs. Here the connection with painting is renounced in order to establish a new relationship with the structure of the complex marble altars in the manner of Sansovino. The grandiose character of the work, the two *Candelabrum-bearing Angels* at the sides of the upper part of the altar, and the figures of *Saint John the Baptist* and *Saint Jerome* in the niche all take their inspiration from Andrea Sansovino. The spacious and resonant structure of the altar recalls the *Sepulchral Monument of Ascanio Sforza and Gerolamo Basso* in Santa Maria del Popolo in Rome (1505-1507). Here, however, the opulence of the decorative sections mars the measured spatial matrix derived from Sansovino; the result is a cumbersome work devoid of the "sense of artistic measure" that Vasari recognized in Sansovino's Roman sculpture.

In the *Lamentation over the Dead Christ* (1514-1515) in the Bargello the pictorial aspect seems to take precedence once again over the sculptural one. The figures stand out in relief from the background of the picture, which contains, along with the cross, a pair of angels, and the symbols of the Passion, and a boundless stretch of landscape with Jerusalem in the distance, surrounded by sunlit countryside against a dark and stormy sky.

This more popular current of della Robbia art includes

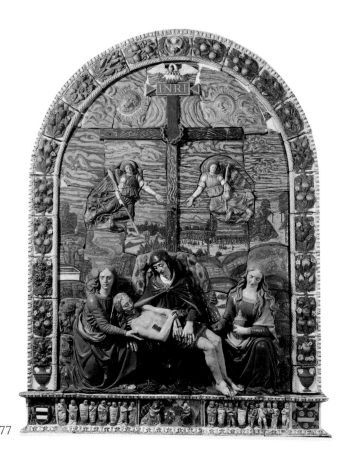

77

the *Nativity* in the Bargello (formerly in San Gerolamo delle Poverine) which was signed and dated by Giovanni (1521), confirming that it had now become necessary to authenticate the works he executed in person, and the *Fonticine Tabernacle* on via Nazionale, dating from 1522. These are both compositions packed with figures and details, rendered in a gaudy, almost obsessive, polychrome. It is in the busts of the Carthusian monastery at Galluzzo that the tendency to draw on antiquity, through the mediation of Renaissance works of classical inspiration, is more apparent than in any other work from Giovanni's entourage.

The complex iconographic and decorative program of the Chiostro dei Monaci (Monk's Cloister), very probably dictated by Buonafede, prior of the Carthusian monastery and one of Giovanni's clients since 1507, comprised sixty-six glazed terracotta medallions depicting figures from the Old Testament — prophets, apostles, and saints. They were mounted on the pendentives of the cloister from 1523 onward. Giovanni's documented activity clearly demonstrates how the relations he maintained with sculptors working in Florence in the early Cinquecento — an example can be found in the *Noli me tangere* in the Bargello, modeled by Rustici in the classical style and with a sort of abstrac-

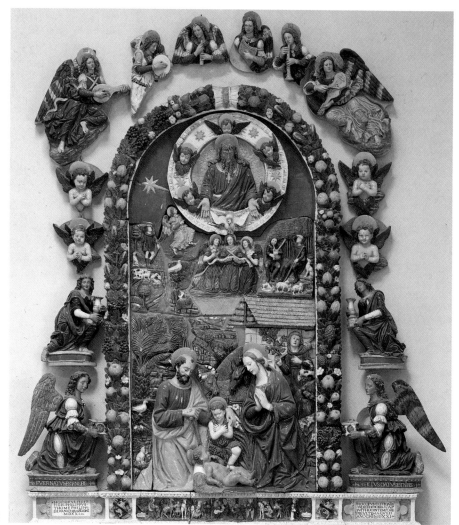

78

77. Giovanni della Robbia
Lamentation over the Dead
Christ
291x235 cm
Florence, Museo Nazionale del
Bargello

78. Giovanni della Robbia
Nativity
280x155 cm
Florence, Museo Nazionale del
Bargello

tion of form for the monastery of Santa Lucia at Camporeggi, and then, as Vasari tells us (1568), glazed in white on a golden yellow ground by Giovanni della Robbia — allowed him to regain his grasp on the sculptural aspect of his art, superseding his frequent earlier compromises with painting.

The death of Andrea della Robbia in 1525, the independent careers pursued by Giovanni's brothers, and the predominantly standardized output of the latter and his entourage led to a progressive decline in the studio on via Guelfa. When, around 1553, over fifteen years after the death of Giovanni and shortly after that of Luca the "Younger" in France, Gerolamo (Florence, 1488 - Paris, 1566) decided to suspend the decorative work he was carrying out for Francis I in the Castle of Madrid in the Bois de Boulogne and leave Paris in order to return to Florence, he was forced to face the fact that, in the prevailing climate of late-Mannerism, he was nothing more than a hangover from the past. He was obliged to return to France, where he died in the year 1566.

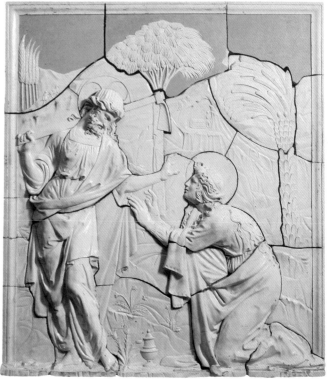

79

79, 80. Giovan Francesco Rustici and Giovanni della Robbia
Noli Me Tangere and detail
230x200 cm
Florence, Museo Nazionale del Bargello

80

71

81

82

The brothers of Giovanni della Robbia: notes on the epigones of della Robbia

About Francesco (Florence, 1477-1527) and Marco della Robbia (Florence, 1468-ca. 1534) who, as Vasari informs us, entered the Dominican convent of San Marco in 1495 and 1496 respectively, taking the names of Fra Ambrogio and Fra Mattia, we know very little.

In 1508 Ambrogio's name appears in documents relating to the works carried out for the church of Santa Maria della Quercia in Viterbo. Ten years later a "della Robbia friar" (perhaps Fra Mattia) received 25 ducats in payment for the floor of the Vatican Loggias, for whose realization Luca the "Younger" had been summoned to Rome by Raphael.

The setting up of a kiln at Montecassiano in the province of Macerata in the second decade of the sixteenth century, the purchase by Ambrogio della Robbia of a house in the parish of Santa Croce at Montesanto (now Potenza Picena), where he served as chaplain, and the predominance of clients from the Marche and Rome for their works suggest that the two monks had moved to the Marche at the beginning of the 1520s, thereby removing themselves definitively from the Florentine artistic scene.

In any case, as early as 1504 Fra Ambrogio had spent a month in Siena, to install a *Manger* in painted and partially glazed terracotta, with movable figures, in the Benedictine monastery of the church of Santo Spirito.

Without a shadow of doubt, however, Luca the "Younger" (Florence, 1475-1548), was the most mature and complete artist among Andrea's sons. A fer-

vent supporter of Savonarola (in 1498 he and his brothers took part in the armed defense of the monk in San Marco), and a friend, along with his brother Gerolamo, of Andrea del Sarto, Luca can be considered the only one of Andrea's descendants who was capable of bringing his father's art into line with the classical trends of the early Cinquecento. Vasari wrote "[…] he was very diligent in glazed terracottas and made by his own hand, along with many other works, the floors of the papal loggias that Pope Leo X had commissioned from Raphael of Urbino as well as those of many other chambers where he made the arms of that pope."

The choice of Luca to work in the Vatican in 1518 must have been a carefully considered one and can be justified by the elegance of the artist's decorative work, quite different from the majority of della Robbia works in the second decade of the sixteenth century. The *Bartolini-Salimbeni Coat of Arms* in the Bargello that the sculptor executed around 1523 is an example of that quest for elegance and preciosity of decoration combined with the ornamental value of the sculpture that must have fitted well with the requirements of the Curia and does much to explain why he was preferred over other members of the della Robbia entourage.

There are very few documents relating to the career of Luca di Andrea. In 1494 he is cited along with his father in the documents of the San Frediano frieze (lost) and in 1500 in those of the della Robbia works for the Chapel of San Bartolo in Sant'Agostino in San Gimig-

81, 82. Giovanni della Robbia and assistants
Saints Lucy and Agatha
Florence, La Certosa Monastery (Galluzzo)

83. Luca the 'Younger'
Bartolini-Salimbeni Coat of Arms
Florence, Museo Nazionale del Bargello

nano. In spite of the scarcity of records, the Vatican commission indicates that even prior to 1518 his art must have had a sufficiently high reputation to justify his official appointment that year by the pope and the artist from Urbino.

In this context, the classical and up-to-date language of the *Adoration of the Shepherds* and the *Deposition* in the church of the Franciscan monastery of San Lorenzo in Bibbiena can be seen as the fruit of a successful marriage of ideas and intentions between the artist and his clients, Leo X and Cardinal Bibbiena, whose coats of arms are set at the ends of the two predellas. The pontifical tiara and the cardinal's hat show that the commission must have been made no earlier than 1513 (the year that Lorenzo il Magnifico's son ascended to the papal throne and gave the office of cardinal to his loyal and capable adviser, Bernardo Dovizi) and no later than 1520, the year of Dovizi's death.

Going beyond Marquand's generic attribution (1922) of the two Bibbiena altarpieces to the studio of Andrea della Robbia and his suggestion that they were the work of one of his sons, we can see that Luca the "Younger" was the closest to some of the formal refinements of his father, given that his brothers were less committed to the traditional and classical style of the early della Robbia altarpieces. The kinship between the *Adoration* in Bibbiena and the *Nativity*, modeled — according to Marquand (1922) — in 1515 by one of Andrea's sons for the church of Santa Maria Maddalena at Pian di Mugnone (Florence), and Bandini's comment in the *Odeporico del Casentino* (18th century) — "[...] two altars excellently worked in terracotta by Luca della Robbia" — strengthen our proposal that Andrea's third-born son was the author of the two works in Bibbiena. This would also explain the extremely refined language of the predella panels. The typology of the faces, the fullness of the drapery, the elegance of the details (note the fawn emerging from the rocky vegetation of the mountains in the scene of the *Stigmata*, in the middle of the *Deposition*, or the figure of brother Leo, with that sudden twisting of his body, surprisingly huddled underneath his heavy frock), and the classical atmosphere that cloaks the *Saint Sebastian* are all elements that lead us to reflect on the influence exercised by the works of Andrea del Sarto and Andrea Sansovino. They also

84

serve to recall the general revival of the classical spirit in those years that helped to "[...] create a trend of perfectible progress in the imitation of the objective and vital side of reality" (M. Calvesi in Var. Authors, *Raffaello in Vaticano*, Milan 1984, p. 166).

Hence we are dealing with a sculptor who was capable of keeping abreast of the times and ready to draw on the new experiments in art in order to redeem a production of *invetriati* that was otherwise obsolete.

A careful examination of the two main scenes reveals that the language of the works belongs to the grammar used by Andrea's studio: while the *Adoration of the Shepherds* is clearly related to the *Adoration* in

84. Luca the 'Younger'
Adoration of the Shepherds
Bibbiena (Arezzo), Church of San Lorenzo

85. Luca the 'Younger'
Deposition
Bibbiena (Arezzo), Church of San Lorenzo

85

Santa Chiara in Monte San Savino, the *Deposition* is closely akin to the *Lamentation* in the Museo di San Marco. Likewise the modeling of Mary Magdalen, who is holding Christ's feet wrapped in a knotted sheet, is reminiscent, especially in the rendering of the face with the hair adhering to the nape and falling in waves over the shoulders, of the *Christ Bearing His Cross* (dated 1513) attributed to Gerolamo della Robbia in the Colloquio of the Certosa at Galluzzo. This is a further reminder of the influence of northern European painting, and that of Dürer in particular, on Florentine art in the early Cinquecento.

All these considerations fit in well with the attribution of these works to Luca the "Younger," the only one of Andrea's sons capable of critically revising the art of his father in the light of contemporary artistic developments.

The part played by Benedetto (Florence, 1461-1521) and Santi Buglioni (Florence, 1494-1576) in the later production of "della Robbias" requires separate discussion. At the end of the Quattrocento, in fact, Benedetto opened a workshop in Florence that specialized, like the one on via Guelfa, in glazed terracotta. It was able, thanks to a language that was simple and familiar and yet of elevated tone, to provide an effective response to the demand for terracotta decorations for buildings

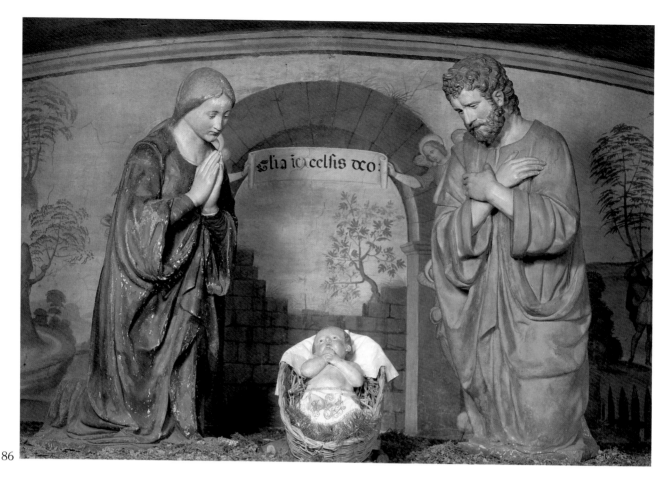

86. Luca the 'Younger'
Crib
Pian di Mugnone (Florence), Church of Santa
Maria Maddalena

87. Gerolamo della Robbia (attr.)
Christ Bearing the Cross
172x77 cm
Florence, La Certosa Monastery (Galluzzo)

in the city and the surrounding countryside. His train-
ing under Andrea and alongside Giovanni — the results
of which can be seen in the modeling of figures like the
Archangel Michael and *Saint Leonard* in the *Madonna
and Child with Saints* in San Michele Archangelo at Ba-
dia Tedalda (1517), drawn from the repertory of An-
drea in the seventies — was combined with the new
ideas that sculptors like Benedetto da Maiano and the
ones associated with the Garden of San Marco (Andrea
Sansovino, Baccio da Montelupo, Rustici, and Tor-
rigiano) were introducing into the Florentine milieu of
the time. Nor did he fail to pay careful attention to de-
velopments in contemporary painting.

A sense of greater breadth and grandeur of style is
to be found in the production of Santi Buglioni, pupil
and relative on his mother's side of Benedetto Buglioni.
The artist belonged to the Florentine culture in the clas-
sical mold of the early Cinquecento. This is apparent
in the work he did alongside Benedetto for Badia

88

89

90

88-90. Giovanni della Robbia and Santi Buglioni
The Seven Acts of Mercy
Visiting the Sick, Visiting the Prisoners, Feeding the
Hungry
Pistoia, Ospedale del Ceppo

Tedalda, such as in the *Annunciation with Saints Julian, Sebastian, and Anthony Abbot* (1522), where the figures take on an unusual agility and elegance in the fluttering of their garments, or in the frieze that runs along the entire length of the loggia of the hospital of the Ceppo in Pistoia, where Santi worked in the 1520s in collaboration with Giovanni della Robbia.

Vasari refers to Santi in his *Life of Verrocchio* as the

only one "who knows how to work this sort of sculpture" and in his *Life of Tribolo* as the latter's collaborator in 1539 on the *Equestrian Statue of Giovanni delle Bande Nere*. This was to be erected in San Marco on the occasion of the entry into the city of Eleonora of Toledo, the wife-to-be of Duke Cosimo, where it seems that "falling, he was crippled in the leg and very nearly died."

With Santi Buglioni, sculptor and decorator — he made the cartoons for the floors of the Biblioteca Laurenziana (1549-1554) and of several rooms in the Palazzo Vecchio (1556-1560), including the chamber of Leo X (1558-1560), as well as for a number of grotesques in the garden of Palazzo Pitti (1556-1560) —, the fascinating story of the della Robbias comes to an end in the middle of the sixteenth century.

Bibliography

L.B. ALBERTI, *De pictura* (1436), ed. by L. Mallé, Florence 1950.

A. AVERLINO (Filarete), *Trattato di Architettura* (1464), ed. by A.M. Finoli and L. Grassi, Milan 1972.

A. MANETTI, *Vita di Filippo Brunelleschi* (ca. 1487), ed. by D. De Robertis and G. Tanturli, Milan 1976.

P. GAURICO, *De Sculptura* (1504), ed. by A. Chastel and R. Klein, Geneva 1969.

G. VASARI, *Le Vite de' più eccellenti Pittori, Scultori ed Architettori* (1550, 1568), ed. by P. Barocchi, Florence 1971; ed. by G. Milanesi, Florence 1978-85.

F. BALDINUCCI, *Notizie de' Professori del Disegno da Cimabue in qua* (1681-1728), ed. by F. Ranalli, Florence 1845-47.

A.M. BANDINI, *Odeporico del Casentino* (18th century), manuscript in the Biblioteca Marucelliana in Florence.

J. CAVALLUCCI, E. MOLINIER, *Les Della Robbia*, Paris 1884.

E. MÜNTZ, *Les collections des Médicis au XV siècle*, Paris 1888.

W. BODE, "Luca della Robbia e i suoi precursori in Firenze", in *Archivio storico dell'Arte*, 1889, II, pp. 1, 9, 127-133.

W. PATER, *The Renaissance. Studies in Art and Poetry*, London-New York 1893.

M. REYMOND, *Les Della Robbia*, Florence 1897.

M. CRUTTWELL, *Luca and Andrea della Robbia and Their Successors*, London-New York 1902.

P. BACCI, "Documenti sconosciuti su Giovanni della Robbia", in *L'Illustratore fiorentino*, 1908, pp. 143 *et seq.*.

A. MARQUAND, *Della Robbia in America*, Princeton 1912.

A. PIEROTTI o.f.m., "Un libro d'amministrazione del Convento della Verna degli anni 1481-1518," in *La Verna*, 1913, pp. 236-254.

A. MARQUAND, *Luca della Robbia*, Princeton 1914.

ID., *Robbia Heraldry*, Princeton 1919.

ID., *Giovanni della Robbia*, Princeton 1920.

ID., *Andrea della Robbia and His Atelier*, 2 vols., Princeton 1922.

R. LONGHI, *Piero della Francesca*, Spoleto 1927.

A. MARQUAND, *The Brothers of Giovanni della Robbia*, Princeton 1928.

M. SALMI, *Paolo Uccello, Andrea del Castagno, Domenico Veneziano*, Milan 1938.

L. PLANISCIG, *Luca della Robbia*, Vienna 1940.

R. SALVINI, *Luca della Robbia*, Novara 1942.

A.M. CIARANFI, entry "Della Robbia", in *Enciclopedia Treccani*, 1949, vol. XII, pp. 551-555.

G. BRUNETTI, entry "Della Robbia", in *Enciclopedia dell'Arte*, 1958, vol. IV, pp. 252-258.

ID., "Note su Luca della Robbia", in Var. Authors, *Scritti di Storia dell'Arte in onore di M. Salmi*, Rome 1962, pp. 262-272.

C. SEYMOUR, "The Young Luca della Robbia", in *Allen Memorial Art Museum Bulletin*, Oberlin (Ohio), 1962-63, XX, pp. 92-119.

E. CAMESASCA, *Artisti in bottega*, Milan 1966.

G. CORTI, "New della Robbia Documents," in *The Burlington Magazine*, CXII, 1970, pp. 748-752; CXVI, 1973, pp. 468-469.

E. MICHELETTI, entry "Benedetto e Santi Buglioni," in *Dizionario Biografico degli Italiani*, XV, 1972, pp. 26-28.

G. CORTI, "Addenda robbiana," in *The Burlington Magazine*, CXV, 1973, pp. 468-469.

C. DEL BRAVO, "L'umanesimo di Luca della Robbia," in *Paragone*, 285, 1973, pp. 3-34.

H.W. JANSON, "The Pazzi Evangelists," in *Intuition und Kunstwissenschaft: Festschrift für Hans Swarzenski zum 70. Geburtstag am 30. August 1973*, Berlin 1973, pp. 439-448.

B. TATTERSALL, "The Birkenhead della Robbia Pottery — Il Progresso sia il Nostro Scopo," in *Apollo*, XCVII, February 1973, pp. 164-168.

J. POPE HENNESSY, "Thoughts on Andrea della Robbia," in *Apollo*, CIX, date ?, pp. 176-197.

ID., *Luca della Robbia*, Oxford 1980.

L. BELLOSI, "Per Luca della Robbia," in *Prospettiva*, XXVII, 1981, pp. 62-71.

G.C. GENTILINI, *Luca e Andrea della Robbia: nascita e primi sviluppi della terracotta robbiana*, graduate thesis, University of Pisa, acad. yr. 1982-83.

G.C. GENTILINI, "Le 'terre robbiane' di Barga," in G. Sodini, G. Spini, *Barga medicea e le «enclaves fiorentine della Versilia e della Lunigiana*, Florence 1983, pp. 203-242.

G.C. GENTILINI, *Le robbiane*, Florence 1985.

F. DOMESTICI, *La riscoperta dei della Robbia in Casentino*, graduate thesis, University of Florence, acad. yr. 1985-86.

ID., "Il mecenatismo di Leonardo Buonafede per l'arredo del Santuario delle Grazie in Casentino," in *Antichità Viva*, XXVII, 1988, nos. 3-4, pp. 35-40.

ID., *La riscoperta dei della Robbia in Casentino*, ed. Primarno, nos. 18-19, Stia 1988, pp. 33-51.

G.C. GENTILINI, entry "Della Robbia," in *Dizionario Biografico degli Italiani*, Rome 1989, vol. XXXVII, pp. 253-299.

G. CONTI, G. CEFARIELLO GROSSO, *La maiolica Cantagalli e le manifatture ceramiche fiorentine*, Rome 1990.

Index of illustrations